陳正雄（賴炳昇攝，1975）

陳正雄

The Sayings of Chen Cheng-Hsiung on Art

畫語錄

陳正雄 著

陳正雄畫語錄

陈正雄画语录

The Sayings of Chen Cheng-Hsiung on Art

陳正雄畫語錄

序

語錄中的智慧
——陳正雄的藝術思維與創見

　　在戰後台灣美術史上，陳正雄（1935-）是頗為特殊的一個案例：在看似非專業學院訓練出身的背景下，卻成為台灣抽象藝術最具專業理解與強力創作成果的一位成功畫家。陳正雄不僅在1991年就已經和趙無極（1921-2013）、朱德群（1920-）同時成為巴黎五月沙龍的少數受邀華人畫家之一，更是義大利佛羅倫斯國際當代藝術雙年展最高榮譽——「終生藝術成就獎」及「偉大的羅倫佐金章」1999年及2001年連續兩屆的得主，為亞洲裔第一人。十餘年來，更多次深入中國內地，以傳者般的熱情，受邀為許許多多的專業美術學院，包括：北京清華大學、北京大學、中央美院、中國藝術研究院、北京人民大學、宋莊美術館、今日美術館、杭州中國美院、四川美院、四川大學、四川師大、成都美院、魯迅美院、南京藝術學院、上海復旦大學、華東師大、交通大學、上海大學、上海師大、上海設計學院、上海東華大學、遼寧師大……等名校講解、介紹抽象藝術的思潮與作品；同時也是1994年上海美術館的諮詢委員及上海美術雙年展的策劃人，可以說是近年來中國畫壇接觸抽象藝術最重要的理論指導者之一。

陳正雄在就讀台北建國中學高中一年級時，曾受業於台灣第一代藝術大師李石樵及金潤作，並從他們身上獲得許多藝術方面的知識與見解。不過，陳正雄對藝術的學習，更重要的是來自自我不懈的學習。由於英日文能力的精湛，他在大學時期，便已讀完英文版的抽象藝術經典名著，也就是康丁斯基的《藝術的精神性》；畢業後，服預官役受訓練期間，又大量研讀英國藝評家赫伯特·里德的《現代繪畫簡史》和《現代藝術哲學》等書。可以說：在初踏上創作的時期，陳正雄對現代藝術的認知，便已經從前輩畫家的基礎出發，進而超越了第一代油畫家的思維。

1960年代，台灣的現代繪畫運動正逢啟蒙出發的時刻，許多對現代主義，乃至抽象繪畫的介紹，都是片面且可能誤解的轉手資訊；陳正雄便以他來自原典研讀的知識，在1965年年中，假《文星》（92期）發表〈談抽象藝術〉一文，深入淺出地從歷史發展的脈絡及藝術理論的角度，為「抽象藝術」的本質提出深具學術性的詮釋與介紹。在這篇先期性的介紹文字中，他寫道：

> 在我們尚未了解抽象藝術之前，首先要明白一點，與其說抽象藝術的特質是描寫的（Descriptive），不如說是召喚的（Evocative）。它就如同音樂一樣，旨在激發內在情感，而非述說故事。它係藝術家內在經驗（情緒、心情或情感等）的一種強烈表徵，是一種視覺的隱喻（Visual Metaphor）而非視覺的敘述（Visual Narrative）。
>
> 藝術作品係激發人們內在經驗的一種工具，這是了解抽象藝術所必須具備的基本概念。就心理學來說，這種概念係由共同聯想

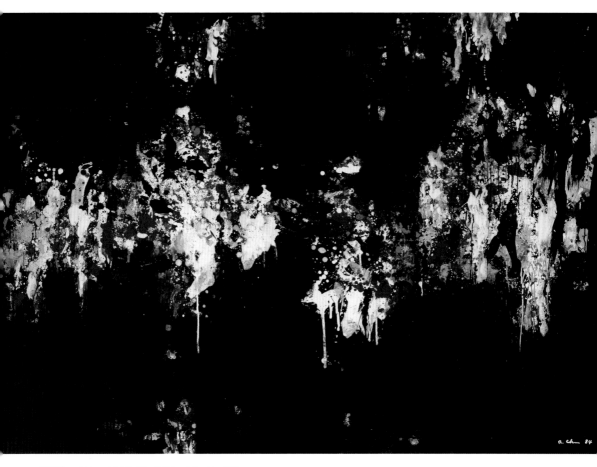

《市夜》，1984，壓克力彩、畫布，130×194公分
THE CITY AFTER DARK, 1984, acrylic on canvas, 130×194cm

（Common Association）與移情作用（Empathy）兩者所發生的。「共同聯想」係指由於自然形象或事物與色彩、形狀、線條之間的關係共同連結而產生了一種特別感覺及概念的過程。舉例來說，紅色似乎往往意指著炙熱或者興奮；黃色表示太陽與愉快；藍與黑則代表冷靜與憂鬱；生物形則表示生命，幾何形則反映理智的構成；地平線則表靜息；對角線則表示行動；而直角則表示穩定。

　　「移情作用」則指人類的想像與外界物體或生物密切聯結的能力而言。就藝術而言，它係指感受梵谷筆下的熱情、馬蒂斯輪廓的優美、孟德里安（Piet Mondria）或布蘭克西（Constantin Brancusi）作品的嚴謹，或者感受羅斯科（Mark Rothko）色彩的寧靜能力而言。

　　在一件含有許多繪畫要素與綜合關係的藝術作品裡，其表現的情感是異常豐富而神妙不可思議的。但這並非所有藝術家均能利用他們的才智去作有意識的安排，以組成這種複雜的關係來傳達一種特有的情緒或心情。其發生的過程往往是不知不覺而且是潛在意識的。大多數的現代藝術家祇覺得需要傳達他們自己內在的情感而根本無意於記錄他們的視覺。真正偉大的藝術家，對於某種經驗特具敏感，並且能把他的內在經驗綜合起來，強烈地表現在他的藝術作品中。舉例來說，大多數的人祇能看見法國南部鄉村的膚淺外表，但塞尚則能看出自然中的邏輯組織與統一；雷諾瓦則發現愉快的美感；梵谷則顯示掙扎與狂熱。故每一位藝術家的獨有特質與內在經驗的強烈能給予他的藝術真正的意義。

《夜之頌》，2003，壓克力彩、畫布，112×162公分
ODE TO NIGHT, 2003, acrylic on canvas, 112×162 cm

1964年，陳正雄以《檸檬》一作，獲得「台灣省全省美術展覽會」油畫部第三名的榮譽，展開他此後長期的專業創作生涯，也成為台灣戰後少數能完全以藝術創作作為專業的成功畫家之一；但他始終保持以文字論述推動、導正抽象藝術發展的熱誠。在此後的日子中，他先後撰就的相關文字，最具代表性者，如：1965年的〈風靡歐美的歐普藝術〉（1965.5.2《徵信新聞》），1967年的〈戰後國際藝壇動向〉（1967.6.3《中央日報》）、〈漫談抽象藝術〉（1967.7.24《台灣新生報》）〈抽象藝術是什麼？〉（1968.7《雄獅月刊》），以及1968年為知名《東方雜誌》撰寫的〈抒情抽象與幾何抽象〉（復刊第1卷第9期）、〈抽象藝術之先驅——立體派與未來派〉（復刊第2卷第6期）、〈談紐約畫派〉（復刊第3卷第12期）等。1980年代，也為甫成立的台北市立美術館館刊《現代美術》撰寫〈20世紀抽象藝術的精神〉（58期），及為《自立晚報》撰寫〈新空間觀念的探討〉（1985.7.10）。到了1990年代後期，出面搶救幾臨流產的「法國當代藝術大展」，又撰〈哈同的抒情抽象與東方書法〉（1997.4.27《自立晚報》）一文。隔年（1998），朱德群「遠東巡迴畫展」第一站在北京中國美術館揭幕，陳正雄恰巧人在北京，躬逢其盛，特為老友再撰〈曙光與朦朧——論朱德群的抽象繪畫〉（1998.7.23《自立晚報》）為之推介。在此前後也為中國大陸美術期刊先後撰寫〈從具象到抽象〉（1994.6《藝術世界》）、〈抽象畫欣賞的美學原則〉（2009.7.10《中國藝術報》）。

　　事實上，自1970年代以來，陳正雄的藝術足跡，遍及歐洲的巴黎、義大利、美國的紐約、舊金山、夏威夷、亞洲的日本等地，也會晤了許多世界知名的當代藝術大師，如：法國的彼爾・阿雷辛斯基（Piere Alechinsky）、馬塔（Roberto S. Matta）、柯奈荷（Willem Corneille）、

德培（Olivier Debre），美國的山姆・法蘭西斯（Sam Francis）、卡雷爾・阿貝魯（Karel Appel）、日本的菅井汲、池田滿壽夫，以及知名藝評家和藝術史家如：英國牛津大學的蘇立文（Michael Sullivan）、美國的約翰・史派克（John T. Spike）、法國的龍柏（Jean-Clarence Lambert）、傑拉・蘇瑞哈（Gerard Xurigera）、義大利的彼爾・雷斯塔尼（Pierre Restany）、日本的植村鷹千代……等。陳正雄與這些當代藝術巨擘互相交流彼此的創作經驗與美學觀，更厚植了他們大師之間的友誼。陳正雄將累積數十年來難能可貴的心得以《陳正雄畫語錄》為名結集出書，成為台灣畫家的第一本畫語錄。這是畫家學習、思索、創作藝術的思維記錄，對藝術家個人而言，是一種學理的整理與呈現，對關懷、學習藝術，尤其是抽象藝術的同好或後輩而言，則是一項極佳的引導與啟蒙。

　　全書計分七個大項，分別是：
　　（一）藝術理念
　　（二）藝術家
　　（三）藝術作品
　　（四）我說我畫
　　（五）抽象畫
　　（六）中西藝術
　　（七）藝術教育

　　在每個大項中，都收錄20至30條左右的語錄，每一語錄的字數，短則1～20字，長則不過百餘字，簡明扼要，且充滿啟發性。如「藝術理念」

乙項中，開宗明義，即謂：「藝術不在表現第一層面的經驗，而在表現第二層面的真實。因為這深層的真實，更純粹、更直指人性。」直探藝術本質的核心，對那些終日以描繪物象表面為目標的「畫家」，予以直接的棒喝。

又謂：「我的藝術旨在探索和傳達我所確信的唯一真實──即內在經驗（感情、情緒、心情）的真相，並藉助繪畫的基本元素和美感形式，探尋內在世界的奧秘，將不可見的內在經驗化為可見的視覺存在。」

有人認為：藝術沒有絕對的定義。這話或許真確，但藝術如果沒有了內在經驗的探尋與呈現，徒然落入固定技巧的搬演，藝術也就不可能在人類的文明中扮演如此重要的角色。此外，或許藝術可以有多元的見解或定義，但就一個嚴肅的藝術家而言，其見解或定義，必形成一種完整的體系，不至紛亂乃至矛盾。

陳正雄的畫語錄，就是陳正雄的藝術見解與定義，同時也是二十世紀抽象藝術的主流思想與定義。固然，抽象不是藝術唯一的形式標準，但由抽象引導、開展的各種藝術見解與視野，卻是人類在二十世紀最偉大的文明成就之一。陳正雄立基於這個人類共同的文明基礎，發展出自我藝術的思想體系，有些或許是個人的，但絕大部份則是人類足可共享的經驗與方向。比如他在「藝術家」乙項中，有謂：「『風格』是表達畫家個人特性和思想的一種方式，是畫家的標誌，它能使作品帶有明顯的個人色彩。一個藝術家建立自己繪畫的風格，也就是有了自己的繪畫語言，有了自己獨特的面貌。從這個角度來看，一位優秀的畫家同時也將是一位繪畫語言藝術家。」又謂：「建立自己的風格難，突破或顛覆已建立的風格更難。藝術家最艱難的工作在於如何不斷地超越自己，尋求突破、顛覆，並不斷地

以新面貌展現自己的藝術內涵。一個藝術家的創作風格停止變化，不能突破，就意味著藝術生命的死亡。」這樣的見解，不論是對抽象或具象風格的藝術家而言，都是不移的真理。

　　針對「藝術作品」，他也有對「非創作者」的一些忠告，如：「買畫是對專業畫家最大的鼓勵，也是對『造美產業』最實質的贊助，它是支持專業畫家不斷工作的工具。創作者有了各方的鼓勵，才能持續專心致力於創作。」又說：「富豪們經常一擲萬金，購買名家的名畫，其中有一部份人的確是基於藝術興趣與品味。但也有不少人常常是為了投資生財、免稅節稅、附庸風雅或博得慈善美名，儘管原因不一而足，無非希望能為銅臭的外表噴上一點藝術香水，亦即把『銅臭味』變成『銅香味』。儘管如此，社會上的藝術風氣和水準會隨著蓬勃提升起來，這也就是著名經濟學家亞當‧史密斯所說的『看不見的手』。」至於對創作者，他也建議：「畫『大畫』不易，作『小畫』亦難。畫『大畫』不是像照片般放大擴張，它必須有足以支撐大畫面的架構及內容，需有深厚的技法基礎以及藝術修養，才能畫出氣勢磅礴、如交響樂般令人震撼的巨幅大作。畫大畫切忌犯『大而不當』，而『大』未必等於『好』。波洛克的巨幅抽象畫，正因為有了上述的前提，才有撼動觀者的美感力量。小畫則是在方寸之地鋪設錦繡大世界。精美的小畫，若看起來仍有『大畫』的感覺和氣勢，才算得上是好畫。克利的小畫就是這樣，尺幅之內卻蘊藏著天文數字的豐富性，非常耐看。」

　　對「抽象畫」這一主題，也是全書相當精華的一個部份。很多人常有「看不懂抽象畫」的困擾，陳正雄也以簡明易懂的語言加以闡述。他說：「寫實畫就如譜上唱詞的歌，美則美矣，然意境有限，雙重限制了創

序　語錄中的智慧

一七

陳正雄畫語錄

作者和接受者的想像力。抽象畫則若無詞的樂曲，乃是一首色彩交響樂，涵蓋著無限豐富的生命。意境猶如不斷膨脹著的宇宙，無論創作者和接受者，都可駕馭著想像乘風而去，它是『視覺的音樂』。」又說：「人生是不自由的，但是抽象藝術能給心靈以『接受美學』上的審美自由，能給人一種天馬行空的境界。」因此他建議：「提昇欣賞抽象畫能力的良方，是營造學習欣賞抽象畫的生活環境。在家中或辦公室裡掛上幾幅優質的抽象畫，和它們生活在一起、工作在一起，營造耳濡目染的審美氛圍。易言之，就是要浸淫在抽象畫的環境裡，這將有助於提升美感品味與對現代藝術的邏輯思考力。從熟悉中體會抽象畫的內涵，不失為了解和欣賞抽象畫的良方。這就如同在家裡經常聽古典音樂一般，能培養對音樂美感的感受力。」

對於部份將抽象繪畫比喻為「中國古已有之」的說法，陳正雄也導正說：「有人認為『抽象畫』的觀念與精神中國古已有之，甚至還說在中國美術史上綿延了三千年之久。事實上，中國美術在古老的『中庸』和『中和』的哲學精神指引下，從來就沒有真正臻於純粹或完全抽象的境界，總是在『具象』與『抽象』之間游移徘徊。我們從唐朝水墨畫家張彥遠的『夫畫最忌形貌采章』，以及北宋蘇東坡的『繪畫以形似，見與兒童鄰』等的繪畫思想，即可看出當時水墨畫家停滯（或游走）於『具象』與『抽象』之間。」他更進一步解釋說：「廿世紀初誕生的抽象畫，其觀念和精神內涵，與中國史前時期的彩陶和三千年前的商周銅器上的抽象『紋樣』截然不同。蓋中國史前時期的彩陶和商周時期的銅器圖案紋飾雖然都是抽象形式的紋樣，但這些紋樣均屬『裝飾藝術』的範疇，而非『造形藝術』的範疇，這是二者本質上與功能上的最大不同。蓋裝飾藝術的創作基本上

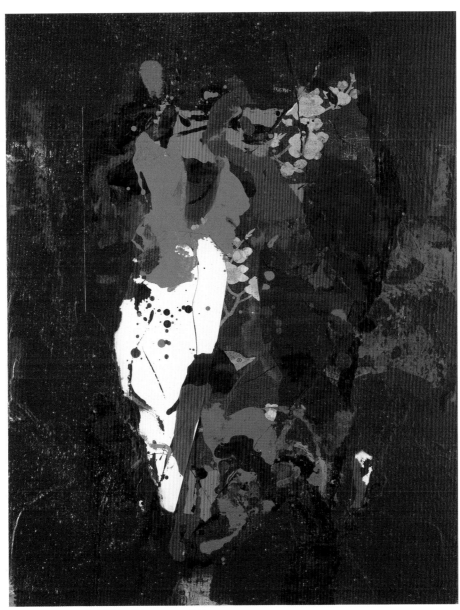

《吉祥》，1991，複合媒材、畫布，53×65公分
AUSPICES, 1991, mixed media on canvas, 53×65cm

是重『實用』和『裝飾』功能，且都無落款；而廿世紀誕生的抽象畫是由繪畫基本元素、形、色、線、空間等所構成和組合，它講究視覺元素間的複雜組合關係，其創作源於藝術家『內在需要』，並傳達其內在經驗的真相及探索內在世界的奧秘。因此，二者不可混淆。」

對於「中西藝術」的比較，陳正雄也有頗為精闢的看法，他認為：「國畫與西畫，其媒材、工具、美學意趣都不同，科學哲學指出，不同規範不可比優劣。因此，二者萬不可楚河漢界，相互藐視，應該相互吸收其長處，將中西畫的特色加以融合。控制論鼻祖維納說，兩個不同學科的交接部往往是一門新學科的產床；那麼，國畫與西畫的交緣，也可期待一種新藝術的誕生。」因此，他主張：「結合西方的表現工具和形式，或吸取西方經驗才是中國水墨畫發展的唯一途徑。中國水墨畫是中國獨特的藝術，它是以筆墨的情趣和意境來展現我國儒家、道家以及佛教的思想。但自宋元以來，即以師承和臨摹為風尚，往往拘泥於中國傳統水墨的技法。今天大部分的中國繪畫之所以如此貧血，會走進死巷，是大部分畫家閉關自守，因循守舊，而不敢放膽創新，痼疾是缺乏多方面的文化營養。其解決之道，可與西方的技法合璧，跳脫摹擬，走向創新。」

在純粹的藝術創作之外，他也關心「藝術教育」；對「藝術教育」的實施，有一套獨特的看法。他認為：「在學校課堂裡學習的知識與技法，不論教材與教法，仍顯得保守，缺少啟發性和創造性，依樣畫葫蘆，很多已經過時，甚至是錯誤的。長期以來，教授美術的課程已經僵化，因此，須要更新教學課程，這樣可縮小教學大綱與最新藝術發展之間的差距。至於社會美術教育方面反倒是比較成功的，儘管其規模是零散的，聲音也不大，但影響力卻是深遠的。」因此他主張：「要成為一個藝術家，不是只

依托學校教育。畢業後必須建立自己的藝術觀，努力走自己的路。老師只是藝術教育者、一位引路人或啟蒙者而已，不是萬能藝術家，美術教育不是培養現在最流行的美術。如果學生只學了老師這一道菜，五年、十年之後，他們就不知所措。譬如說吧，目前裝置藝術風行全台，美術館也經常舉辦，但裝置藝術在美國早已開始式微了，那學校還要不要再教裝置藝術呢？所以，學校裡的課程要有現代規畫。不是教會學生某種新流派，而是讓學生受到現代藝術觀念、技法與原創意識的訓練；換句話說，不是給學生一隻鳥，而是給一把能打鳥的槍，這就是教師與做一個藝術家的不同之處。」

對於自己的創作，他在「我說我畫」項下，指出：「我的作品一幅幅都用色彩表現出生命在大自然中的躍動和歡愉。」他說：「我的每幅畫都是在不斷冥想的過程中隨機完成的。米開朗基羅對著大石頭冥想，待看到石頭中的激動，他才開始動刀。我在動筆前，像日本茶道那樣靜靜坐在畫布前，凝視著空白的畫布，冥想出意境，再由意境構想出造形和色彩。這時嘴裡念念有詞說：『啊！我要這樣畫！』立即動筆，急切地把那藏匿的內在經驗投射到畫布上。所以我在空白畫布前冥想的時間，有時會超過實際作畫的時間。」他解釋：「我畫畫從來不打草稿，一向採取『自然生育』的方式。我直接把顏料潑灑在畫布上，把內在生命與情感直接訴諸作畫行動，就像女人的『自然生育』一樣，不是『剖腹生產』。如此，畫家內的生命與情感才不會被減弱或歪曲，而產生了不自然的『人工生育』。我認為，若透過草圖小心翼翼地作畫，難免會減弱內在的生命力。」因此，他總結自己的創作說：「我從本質藝術（essential art），即從色彩、造型出發，讓色彩成為觀者與畫家間視覺與精神的橋樑，讓觀者

能跨越門檻，進入那五彩繽紛、燦爛奪目的世界，並把繪畫提昇到精神層面。康定斯基說過，抽象畫就是色彩與形象的一種安排與組合，所以如果能夠從本質藝術出發的話，那麼色彩與形象可以發揮得更生動、更完美。」

　　總之，這些看似瑣碎獨立的語錄，其實有著藝術家長期思考、實踐的心得與經驗為基礎，形成了一個完整的思想體系，稱之為「陳正雄的藝術觀」或「陳正雄的藝術思想體系」，亦非過語。其中，有許多帶著現代科學思維的說法，尤具獨創性和啟發性；如論及「藝術理念」時，他以現代生物基因學的理念，提出：「藝術的創作頗像生物科技的基因工程。生物要產生新的品種，必須引入新的基因組接出新的基因鏈。創作也一樣，希望有新的風格、新的形式、新的內容出現，就必須要有新的藝術基因來組接。顛覆與重建，可說是現代藝術的基因工程。我個人就是用所謂『現代繪畫基因工程』的觀念來重建與突破的。對我而言，每次的突破、顛覆意味著更多、更大的挑戰與冒險；而不突破、不顛覆則是更大的不安與痛苦」又說：「藝術家需要建構自己的藝術基因庫，懂得從異質文化的藝術寶庫中尋找新穎的藝術基因，加以萃取後，以創造新物種的方法，創作出無疆界的藝術作品來，這才是上上策。我從台灣原住民藝術中萃取了兩種『基因』：強烈的色彩和鮮活的生命力，也從唐朝的狂草裡萃取豐富的圖像及音樂性，它給我的繪畫引進了新的創造基因鏈，產生新種的藝術產品，所以我的繪畫創作其實是一種繪畫的基因工程。」因此，他認為：「文化的創造活力一如生物的基因重組，多元的文化基因，自能產生泉源活水般的創作生機和成果。因此對不同文化要多學習、多認識、多交流，並加以認同。『去文化』則是對創造力的殺戮。」這是相當有趣又具學理的說法。

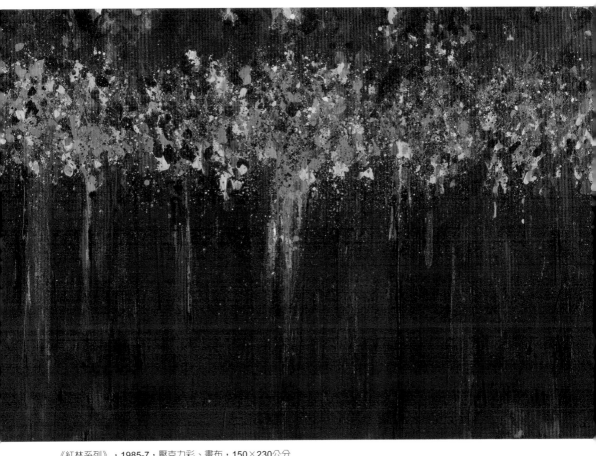

《紅林系列》，1985-7，壓克力彩、畫布，150×230公分
RED WOODS SERIES, 1985-7, acrylic on canvas, 150×230cm

另外，論及「抽象畫」時，他也說：「上個世紀末開始，人類進入數位時代。這以『0』與『1』兩個最簡單數字元素所建構的虛擬空間，改變了整個人類的生活方式。人們通過網際網路來到一個信息浩渺的無垠空間，我強烈地想要以繪畫來表現這個觸摸不到的神奇空間。我想這抽象的三度空間，唯有以表達內在經驗為訴求的抽象繪畫，才能靈動變現。」

　　藝術創作是一項艱鉅的文化工程，每位創作者如何界定自己的定位，也影響到藝術家自我要求及自我努力的標準。陳正雄說：「如果把藝術創作的層次比喻成金字塔的話，大致上可概分為三個層次。金字塔的頂端是極其少數，能跨時代建立起新藝術價值觀者，包括各主義畫派的拓荒者與先驅者，如畢卡索、馬諦斯、康定斯基、杜象……等人，他們像科學上的牛頓、愛因斯坦，不但建立了新的藝術價值觀，開創藝術新視野，且其藝術觀深深影響了以後的藝術發展，居功厥偉。第二個層次為已建立了自己風格的藝術家，他們能建立自己獨特的藝術語言與面貌，已屬不易，可算是相當成功的藝術家。如果他們能不斷地突破既有之風格，並不斷地以新面貌展現自己新的藝術內涵，則將更難能可貴了。底層則為絕大多數未能建立自我風格的一般畫家。」又說：「真正藝術家的創作並不在乎觀者能否了解或欣賞。若畫家為了迎合世俗，畫一些迎合繪畫市場導向的畫作，雖然能賣畫，解決畫家生活的問題，但那只是出賣技巧而已。如此只會抹殺其藝術價值和前途。所以，藝術家要淡薄名利，視富貴如浮雲，才能創作好的作品。真正有成就的藝術家都是專職創作的專業畫家，他們均以創作為職業，並引以為榮。」顯然陳正雄正是以這樣的標準自我定位、自我要求，也不斷努力。

作為一個專業的創作者，陳正雄始終勤於吸納、研究，及筆耕。他既是台灣原住民藝術知名的收藏者與研究者，也是中國宮廷服飾的專家。而在現代藝術，尤其抽象繪畫的論述上，他早在1991年，即為台灣省立美術館（今國立台灣美術館）撰寫《抽象畫》一書；隔年（1992），又著《抽象藝術的誕生與發展》一書，由台北市立美術館出版。

　　這十多年來，他應邀前往中國大陸講學四十餘次，也應北京清華大學藝術學院之邀，撰就《抽象藝術論》一書。如今《陳正雄畫語錄》的出版，讓我們在嚴謹的學術論述之外，更貼近地深入這位傑出藝術家的思維天地，不論是欣賞、創作、收藏，都是一本極佳的入門導論，值得人手一冊，傳閱八方。

<div align="right">蕭瓊瑞</div>

<div align="right">2012年5月</div>

<div align="right">（本文作者為台灣國立成功大學歷史系所美術史教授）</div>

序

康定斯基式的作風

1

我在巴黎採訪國際著名抽象畫家趙無極時，有過如下的對話。

我在趙無極的畫室中指著他的一幅三聯畫問：「在這幅作品中，傳達了您什麼樣的內在體驗、感悟或者是觀念？」

趙儒雅地一笑，答道：「哈，我要是說得出來就不畫了。」

我被他友善地揶揄之後領悟：哦，畫家是只畫不說的，或者說畫家是以畫代說的。

然而，我走出畫室一省思：未必。創立抽象主義繪畫的開山祖師康定斯基（Wassily Kandinsky, 1866-1944）不是又畫又「說」的大畫家嗎？他在任教於德國包浩斯學院時著書立說，出版了《藝術的精神性》、《回憶錄》、《點、線、面》等著作。

我們就此作個思想實驗。假定康定斯基當年只畫不說，那麼後人就完全無法真正明瞭他創立抽象繪畫的原宗旨，只能做出種種莫衷一是、空耗智慧的猜想。由此，可能會認為他的作品不過是任意塗鴉，或者把寫意畫、裝飾圖案等誤讀為抽象畫。倘若是這樣，抽象主義概念的內涵與外延

將全是猜測而不能確定，那麼抽象主義就在混沌中被混掉了。因此，康定斯基要畫也要說。

陳正雄不僅在繪畫上兩度榮膺佛羅倫斯國際當代藝術雙年展「終身藝術成就獎」，及「偉大的羅倫佐金章」，是亞洲裔第一人，而且也出版論著《抽象畫》（國立台灣美術館）、《進入抽象藝術》（合著，台北市立美術館）、《抽象藝術論》（北京清華大學出版社），現在還要出版這本《畫語錄》，成為台灣畫家的第一本畫語錄。

無疑，這是康定斯基的作風。

<div align="center">2</div>

陳正雄的《畫語錄》，用的是歷史悠久的語錄體文體。

這種文體早在人類「文明軸心時代」就盛行了，古希臘有《柏拉圖對話錄》，而中國孔子的弟子們也編撰了記錄孔子語錄的《論語》，歷經幾千年仍然彌新。究其原因，對於作者來說，能最大限度地自由表達，行文無掛無礙，思維跌宕跳躍，段落之間不受邏輯約束；對於讀者來說，作者心靈中深奧的學理往往被化作靈動、易懂的感性語言來表達，因而讀者的閱讀量小而信息量大，還有著很強的被啟動出創意思維的啟動能。

陳正雄從事繪畫一甲子，一邊畫畫一邊思索，一有中國佛教禪師似的頓悟，馬上記錄下來。他熟諳英語、日語，走遍世界，直接與世界正領風騷的畫家同道們交友暢敘，在這般閱讀他人大腦的最具活性的閱讀中，常有火花被對撞出來，恐其稍縱即逝，立即記錄到小本子上。他還是一位很受歡迎的「講座教授」，常被世界各地的高等學府請去講座，思維新銳的學子們常常會在課堂上提出一些意想不到的「聰明的問題」（愛因斯坦

語），陳正雄在回答之後趕快記錄了下來。凡此種種，就錘煉成了這裡的畫語錄106條。

漢語中常用「與君一席談，勝讀十年書」的成語來形容受益匪淺的談話所得。在你讀這本語錄時，這個「勝讀十年書」的歷史記錄被遠遠突破了。陳正雄思索了60年的徹悟，他只用了高度凝練的12000字表達，換句話說，讀者你只需要用一個小時的閱讀就能全收，那麼，假定你的智商比作者高一倍，那你還勝讀了30年書！何況，你比這位「臺灣抽象畫教父」更聰明還是個假定。

<div align="center">3</div>

畫語錄是否只是畫家寫給畫家看的文本呢？

臺灣《聯合報》是臺灣乃至海外華人中最有影響的報紙之一。它的副刊──「聯合副刊」──也是蜚聲臺灣藝術界與藝術愛好者的園地。這家副刊總編輯在閱讀了陳正雄的畫語錄之後，破天荒地進行了連載，迴響甚好。副刊的廣大讀者當然不都是畫家，而是一個藝術、特別是文學的愛好者的大群體。獲得這個藝術泛群體的青睞意味著什麼？意味著陳正雄的畫語錄不是在講述繪畫技法，而是在講述所有藝術創新乃至所有思維創新的通衢所在。

不妨信手拈來幾條：

──創意作品是永遠不死的；沒有創意，作品未生即死。

──跟著前人的腳步走，或走別人走過的路，你將永遠落後一步，

永遠扼殺自己的風格。新路是故意的落荒者走出來的，前面沒有路，就自己開路。

——突破，應該是沿著藝術史軸線的「加法」，即要加進「更新穎而精緻的形而下表達」、「更精深而契合潮流的形而上意義」，或者是「對世界嶄新的感知方式」等等。

——創新的機理是自我顛覆，這等同於自殘。無論是自我壓迫，還是自殘，都是自找的苦。因此德國大詩人歌德才會說，「藝術的根是苦的，因此其果實才會是甜的」。

——繪畫藝術在為人類大眾開拓新的視覺空間，這要合群。然而，真正的創新又是曲高和寡，疏離人群。一個要合群，一個是不得不離群，藝術家就在這二律背反中受罪。苦啊！這是藝術家的原罪！宿命的原罪！

讀完以上引來的幾條語錄，就可知道它對一切創造者的普適性了。

因此，這本語錄，畫家讀來可能會有「茅塞頓開」之感，非畫家卻崇尚創意的人們讀後也會有「人同此心、心同此理」的共鳴與激盪。

4

從心靈裡流出來的，才可能如山澗春溪般順暢地瀉流到他人的心田去。

陳正雄的畫語錄，正是從他積累了六十年內在真實經驗的藝術心靈中汩汩流淌出來的⋯⋯。

祖慰

2011年9月於巴黎

（本文作者為旅法作家、陳正雄傳記《畫布上的歡樂頌》作者、
上海同濟大學教授、2010年上海世博會世博局顧問）

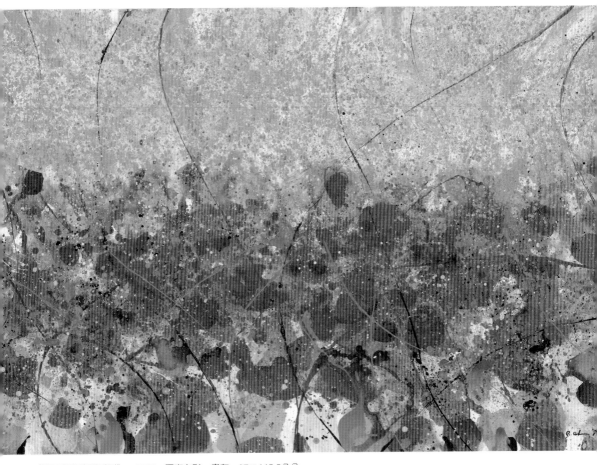

《春天裡的春天系列》，1998，壓克力彩、畫布，97×145.5公分
SPRING WITHIN SPRING SERIES, 1998, acrylic on canvas, 97×145.5 cm

陳正雄畫語錄

【壹】藝術理念

1. 藝術不在表現第一層面的經驗，而在表現第二層面的真實。因為這深層的真實更純粹、更直指人性。

2. 我的藝術旨在探索和傳達我所確信的唯一真實——即內在經驗（感情、情緒、心情）的真相，並藉助繪畫的基本元素和美感形式，探尋內在世界的奧秘，將不可見的內在經驗化為可見的視覺存在。

3. 我深信，一位真正的藝術家會對某些經驗特具敏感，並且能把內在經驗綜合起來，強烈地表現在他的作品裡。這時，他只知道傳達其內在經驗的真相，而對感官和知覺的記錄一點也不感興趣。

4. 我的藝術是「召喚的」，而非「描繪的」。如同音樂，旨在激發內在情感，而非記錄自然的外貌或述說故事。它是內在經驗的一種強烈表徵，是視覺的「隱喻」，而非視覺的「敘述」。

5. 寫實畫家是畫肉眼所見的現實世界，誠如亞里士多德所倡導的旨在「摹仿自然」，往往記錄下自然或現實的皮相外貌。自從照相機發明以後，攝影家已將摹仿自然表現到了極致。現代畫家若能在作品裡傳達觀念或內在經驗的真相，那將會更真實，更有意義，更能發現畫家自己。

6. 藝術創作是一種直覺的衝動。畫家是藉助基本繪畫元素，將其表現或傳達出來。通常，藝術理論均是在新創作出現之後經過數年歸納演繹才產生的；也就是說，先有「藝術作品」，然後才有「藝術理論」。所以，藝術理論是後起的，不領導創作的。二者具有相輔相成的關係，而理論則扮演輔佐的角色。

7. 現代藝術都是由觀念主導創作。藝術家倘若沒有獨特的觀念，只是「空白」創作的話，作品會被掩埋在歷史塵埃中。藝術創作是個人的，唯有個人才能獨特，具有個性化觀念的作品才會獨秀於林，而被藝術史保存下來。

8. 靈感無時不有，無所不在，但只有藝術家的「妙手」，才能把握機會捕捉住這突如其來的「暴發性原創」。藝術家正如音樂家或詩人，必先具有豐富的感情與深厚的學養，才能在孕育出靈感時，以純熟的技巧來捕捉住靈感，並藉著繪畫元素將其表現出來，創造出令人神往的傑作。

9. 創意作品是永遠不死的；沒有創意，作品未生即死。

10 不走別人走過的路或跟著前人的腳步走，不唱與別人一樣的調。當看到到處都是「似曾相識，千佛一面」時，即使已被主流輿論奉為金科玉

律，也千萬不要再跟著玩下去。跟著前人的腳步或走別人走過的路，你將永遠落後一步，永遠扼殺自己的風格。新路是故意的落荒者走出來的，前面沒有路就自己開路。

11. 藝術的創造雖是自我的表現，但也可表達民族或全人類的情感。創造不必局限於情感，要像淘金者一樣，千萬次沖刷出深刻而微妙的新觀念來，這才能使得自我放大成人類。

12. 藝術的創作頗像生物科技的基因工程。生物要產生新的品種，必須引入新的基因組接出新的基因鏈。創作也一樣，希望有新的風格、新的形式、新的內容出現，就必須要有新的藝術基因來組接。顛覆與重建，可說是現代藝術的基因工程。我個人就是用所謂「現代繪畫基因工程」的觀念來重建與突破的。對我而言，每次的突破、顛覆意味著更多、更大的挑戰與冒險；而不突破、不顛覆則是更大的不安與痛苦。

13. 藝術家需要建構自己的藝術基因庫，懂得從異質文化的藝術寶庫中尋找新穎的藝術基因，加以萃取後，以創造新物種的方法，創作出無疆界的藝術作品來，這才是上上策。我從台灣原住民藝術中萃取了兩種「基因」：強烈的色彩和鮮活的生命力，也從唐朝的狂草裡，萃取豐富的圖像及其音樂性，它給我的繪畫引進了新的創造基因鏈，產生新種的藝術產品，所以我的繪畫創作其實是一種繪畫的基因工程。

14. 文化的創造活力一如生物的基因重組，多元的文化基因，自能產生泉源活水般的創作生機和成果。因此對不同文化要多學習、多認識、多交流，並加以認同。「去文化」則是對創造力的殺戮。

15. 創造是將已有的各種元素加以新的組合，它不是無中生有，而是原有的各種元素因重新組合，而衍變出不同的成果。在自然科學領域中，創造意味著進步與提昇，但在藝術的範疇裡，並沒有所謂進步。與其說創造是進步的，不如說是人類固有的「視覺形式」之新發現。事實上，整個美術史就是一部「視覺形式」發現的歷史，所以藝術上沒有什麼進步、不進步的說法。

16. 畫之三不主義：（一）不仿古人：畫畫不可照抄古人，不走古人走過的路，要從古畫中走出來。（二）不仿今人：仿今人與仿古人是一樣的。（三）不仿自己：不要抄襲自己、重複自己，要勇於挑戰自己的過去，再創造新的內涵及面貌，才能提昇藝術價值。

17. 藝術的本質是創新，要創新一定有很大的壓力，有壓力才能突破。這壓力不是來自外部，而是自己。一個藝術家若輕輕鬆鬆作畫，沒有壓力，絕不可能突破，更談不上創新。創新的機理是自我顛覆，這等同於自殘。無論是自我壓迫，還是自殘，都是自找的苦。因此德國大詩人歌德才會說，藝術的根是苦的，因此其果實才會是甜的。

18. 一個人如果興趣跟事業相配合，那是最好、最幸福的。但喜愛藝術創作，可能會經濟拮据潦倒落魄，要有心理準備才好。要做自己喜歡的事，就要勇於面對一切困難。遇到挫折不可輕言放棄，要執著、不妥協、不變節，最後才能看到成果。藝術創造的歷程艱難崎嶇，沒有什麼捷徑可一蹴而得。

19. 藝術不是短程衝刺，它是跑一輩子的馬拉松競賽。一個藝術家必須能在長期艱苦、孤單的環境中，展現出「路遙知馬力」的「執著」與「專業精

神」。

20. 「人生短而藝術長」，藝術是一種短暫與永恆的生命覺悟，創作更是一條孤單、艱苦的漫漫長路。真正的藝術家，宿命地要一輩子無怨無悔地堅持。

21. 我個人不認為藝術創作必須與人生經歷的痛苦、不幸……等畫上等號。藝術史上有名的藝術大師，並非人人都活在愁苦中。魯本斯是個樂天派，哥雅很懂得自娛，梵谷也很滿意自己的繪畫工作。我覺得世上沒有比畫畫更有趣的事。我認為藝術家的生活，就像是一場令人心醉神迷的夢，只要一天不畫畫或冥思，心裡就會覺得缺了什麼似的。藝術是我的信仰，我的一切。

22. 與藝術大師或大思想家直接會晤、交談、思辯，可以高效率地閱讀他們的大腦，聆聽大師的智慧，從他們那裡汲取各自獨特的思維模式、生活風範、藝術觀念、技巧和經驗，引進自己的藝術基因庫，尋求組接出自己的藝術風格的新「物種」。

23. 突破過去傳統的思考、技法和訴求，才有可能在創作上有所進展，這幾近是公理。然而這種突破，應該是沿著藝術史軸線的「加法」，即要加進「更新穎而精緻的形而下表達」、「更精深而契合潮流的形而上意義」，或者是「對世界嶄新的感知方式」等等。

24. 藝術家對傳統不只是要接受，還要能提昇。對傳統了解得越深厚，提昇就越容易。

《蝴蝶夢》，2005，壓克力彩、畫布，130×192公分
BUTTERFLY'S DREAMS, 2005, acrylic on canvas, 130×192 cm

25. 藝術是一種視覺語言，係由純粹的造形元素——色、形、空間、線及點等所組合及構成。因此，僅靠文字，實在不足以傳達其內涵。

26. 法國名作家、諾貝爾文學獎得主卡繆曾經說過，藝術家是為美與痛苦而工作；我則為美與快樂而工作。現代人壓力大、生活緊張、焦急煩亂與心情浮動不安，痛苦很多，那不是我想要表現的。人們已經夠苦悶了，我不想讓賞畫者再感受抑鬱與煩悶。我要畫出人生的愉快、喜悅、熱情、光明、自由與美麗的一面，並讓人們的視覺重獲舒暢與自由，就像貝多芬的《快樂頌》。我要在畫布上畫出我的《快樂頌》。

【貳】藝術家

27. 藝術家有三種類型：（一）一種就像影歌星，很會作秀，喜歡炒作新聞，善於宣傳，是商業型、明星型藝術家。（二）另一種藝術家的作品一流，具原創性，但不願作秀，不善於宣傳，名氣沒有那麼大，是專業型藝術家。（三）最後一種是一流藝術家，優游於商業與藝術之間而收放自如，是兼顧藝術與商業的藝術家。

28. 藝術史所肯定的是持續長期創作所累積的藝術成就。然而，長江後浪推前浪，前輩藝術家如不能「與時俱進」，不斷創新，就會像時裝或電子產品那般，被逼出舞台。倘若這樣，「累積」就會被阻斷，功虧一簣。

29. 在資訊發達的E時代，現代藝術家不但背負著承繼本土傳統的使命，也肩負著國際藝術新潮創作的責任。因為，現代藝術是無疆界的。

30. 現代的藝術家較易被外在表面的商業包裝、掌聲……等所矇蔽，忽略藝術內在蘊含的動人力量，十分可惜。真正能「感動藝術史」的，唯有內

在蘊含的藝術感情力量。

31. 成名是一件好事，但成名後不可原地踏步，應更加努力突破，這樣才能不斷爆出火光，才有更大的成就與聲名。藝術家無不感嘆「成名容易保名難」。

32. 繪畫藝術在為人類大眾開拓新的視覺空間。然而，真正的創新又是曲高和寡，疏離人群。一個要合群，一個是不得不離群，藝術家就在這悖論中受罪。苦啊！這是藝術家的原罪！宿命的原罪！

33. 「作秀」是對專業的「褻瀆」。有些畫家喜歡作秀，那些動作只會干擾創作，對藝術創作毫無助益。

34. 學畫，並非人人可以成為畫家。在人類歷史中，從事藝術創作的人多如銀河繁星，而能在美術史留下名字的，卻只有寥寥無幾。這說明了一件事：藝術家是從事多彩多姿的高風險事業，是一種永遠沒有退休的行業。對於學畫的人，我要奉勸他們，學畫是為了接觸美的事物，豐富自己的生活，成為專業畫家並非目的。我由衷地期待他們在快樂的學習過程中，能夠培養出對「藝術之美」的欣賞能力與像「藝術品」那樣美的人格品味。

35. 藝術是一項永無止境的工作。我從十七歲開始學畫以來，一甲子的歲月，一直都在「上學」，不斷攻讀「新學位」，沒有畢業可言。

36. 如果把藝術創作的層次比喻成金字塔的話，大致上可概分為三個層次。金字塔的頂端是極其少數，能跨時代建立起新藝術價值觀者，包括各主

義畫派的拓荒者與先驅者，如畢卡索、馬諦斯、康定斯基、杜象……等人，他們像科學上的牛頓、愛因斯坦，不但建立了新的藝術價值觀，開創藝術新視野，且其藝術觀深深影響了以後的藝術發展，居功厥偉。第二個層次為已建立了自己風格的藝術家，他們能建立自己獨特的藝術語言與面貌，已屬不易，可算是相當成功的藝術家。如果他們能不斷地突破既有之風格，並不斷地以新面貌展現自己新的藝術內涵，則將更難能可貴了。底層則為絕大多數未能建立自我風格的一般畫家。

37. 真正藝術家的創作並不在乎觀者能否了解或欣賞。若畫家為了迎合世俗，畫一些迎合繪畫市場導向的畫作，雖然能賣畫，解決畫家生活的問題，但那只是出賣技巧而已。如此只會抹殺其藝術價值和前途。所以，藝術家要淡薄名利，視富貴如浮雲，才能創作好的作品。真正有成就的藝術家都是專職創作的專業畫家，他們均以創作為職業，並引以為榮。

38. 參加畫展是走向職業畫家的方式之一，但參展不代表全部。而得首獎的人未來的發展也不一定比無名次的人好，因為它只是個藝術生涯的開始或者連開始都沒有。只有謙虛、努力、自信、熱情、堅韌，我相信是成為一位成功畫家的必備條件。

39. 快速成功對不少人來說已習以為常，這在許多行業可以行得通，尤其是高科技產業，但對建立獨特風格的藝術家而言就不是這麼一回事。真正的藝術創造過程都是艱難漫長的，沒有什麼捷徑可一躍而達頂峰，故藝術不能急。成功之路必需花漫長的時間，苦心孤詣去經營。然而時代節奏的改變，使得許多從事現代藝術的人用藝術的「麥當勞快餐」加激素灌食，希冀速食速長。

40. 藝術家不同於運動員或歌星，經由五年十載的短期努力和訓練便可成就。在藝術創作這塊土地上，需要藝術家投注生命和熱情全力及長期耕耘，方可發芽抽枝，開花結果。

41. 作為一個畫家，最重要的特質，第一要執著，堅守他的藝術立場，執著於他的創作理念，不變節、不妥協，始終如一。第二必須有專業的精神，忠於藝術、忠於自己，不要心有旁鶩、偏離正軌。不能「冬天賣熱，夏天賣冷」地去迎合繪畫市場的口味。具備執著與專業精神，無怨無悔，才能成為一個真正的畫家！

42. 畫家必須尋找自己的繪畫語彙，而不是一味地跟隨在美、法等國大師的後面賣力模仿，拾人牙慧。因為即使你模仿得再好，充其量也只是別人的影子，永遠不會有自己的「品牌」。品牌的建立非一蹴可幾，必須投注生命，長期耕耘。

43. 只有平凡的畫家與作家才會循規蹈矩地使用別人的繪畫語言和文字。真正的藝術家必然深刻了解「青出於藍而勝於藍」的道理，絕不會滿足於「等於藍」的境界。

44. 「風格」是表達畫家個人特性和思想的一種方式，是畫家的標誌，它能使作品帶有明顯的個人色彩。一個藝術家建立自己繪畫的風格，也就是有了自己的繪畫語言，有了自己獨特的面貌。從這個角度來看，一位優秀的畫家同時也將是一位繪畫語言藝術家。

45. 建立自己的風格難，突破或顛覆已建立的風格更難。藝術家最艱難的工作在於如何不斷地超越自己，尋求突破、顛覆，並不斷地以新面貌展現

自己的藝術內涵。一個藝術家的創作風格停止變化，不能突破，就意味著藝術生命的死亡。

46. 偉大的藝術家須走在時代之前十年、五十年或更遠。

47. 藝術的先驅者和叛逆者永遠不畏挑戰。他不但要超越別人，更須超越自己。即使超越了所有的人，也不該自滿而怠惰下來。當然，最難的超越，正是已經成功的自己。

48. 偉大的藝術家，一如科學家牛頓、愛因斯坦，探險家馬可波羅、哥倫布等，有一種勇往直前的無畏精神、一種憨勁傻氣，深入藝術領域的「萬徑人蹤滅」之地進行探險。

49. 凡是在藝術上有一種新的思想或流派出現的時候，必定會受到一些保守人士的抨擊或謾罵。如果沒有堅強的信心與意志，那是會被擊倒的。從事前衛藝術創作是一條孤單而艱苦的漫漫長路！

50. 共產主義國家都由政府來照顧藝術家，因過度保護藝術家，像把鸚鵡放在鳥籠中養起來，以致藝術家生活過得太安逸優渥，結果是創作的活力與靈性被銷蝕，而無法如莊子的鯤鵬扶搖九萬里、浪擊三千里了。

51. 畫家可兼理論家，如康定斯基，但不可畫家兼藝評家──不可球員兼裁判。但有些人集畫家與藝評家大權於一身，權力魔杖使他不再是畫家，也不是藝評家，角色混淆而淪為藝術掮客。

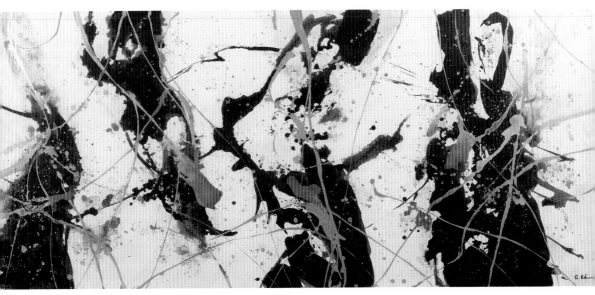

《海天藍的交響》，2008，壓克力彩、畫布，95×227公分
THE SYMPHONY OF BLUE SKY AND SEA, 2008, acrylic on canvas, 95×227cm

52. 廿世紀的兩位藝術大師畢卡索與馬諦斯，他們各自建立了新的藝術價值觀，影響整個廿世紀藝術之發展。他們一生創作的繪畫作品，主題與風格多元，變化多端，十分豐富，每個時期都有不同的內容與風格。尤為可貴的是，他們作品中所傳達的自由感，正是現代藝術家乃至現代人的維他命。

53. 美術家閱讀美術書籍，不只要「看畫」，也要靈悟其「內文」，以領略其創作的思想觀念與創作背景，這樣才能加深對作品的認識與感受。

54. 國際當代藝術雙年展就像個大市場，有好的貨品（有創意的作品）才能獲得青睞，沒有好的作品，就沒有人問津。這個「國際市場」永遠有學不完的東西。不僅如此，畫家若能受邀參與國際大展，跟來自其他不同國家地域的畫家競爭，產生新的「激活因子」，來日必有連自己都覺得驚異的神來之筆。

【參】藝術作品

55. 藝術品是空間最好的美容聖品，而牆壁是為藝術品服務的。若在冰冷的牆壁上掛一幅好畫，頃刻間便能使蓬蓽生輝，生氣盎然，像上帝創造亞當那樣，手指一點，就有了生命的精、氣、神。

56. 買畫是對專業畫家最大的鼓勵，也是對「造美產業」最實質的贊助，它是支持專業畫家不斷工作的工具。創作者有了各方的鼓勵，才能持續專心致力於創作。

57. 富豪們經常一擲萬金，購買名家的名畫，其中有一部份人的確是基於藝術興趣與品味。但也有不少人常常是為了投資生財、免稅節稅、附庸風

雅或博得慈善美名，儘管原因不一而足，無非希望能為銅臭的外表噴上一點藝術香水，亦即把「銅臭味」變成「銅香味」。儘管如此，社會上的藝術風氣和水準會隨著蓬勃提昇起來，這也就是著名的經濟學家亞當・史密斯所說的「看不見的手」。

58. 過去華人富豪的慈善捐贈受傳統文化和宗教影響，除了對宗教做功德為來生求福報外，通常是一毛不拔的。這二十年來，好不容易有企業家感到有一種回饋社會的義務，拿出一些錢，設立文化藝術基金會，幫助藝術文化工作的推動。對華人來說，這是很了不起的文明轉捩點。而義大利十六世紀文藝復興時期的梅西迪家族、美國的洛克菲勒以及保羅蓋帝等扶植藝術的楷模，他們早就懂得這樣做了。我們的富豪比梅西迪家族晚了500年。

59. 主宰作品的好壞，不在「漂亮」，而是「創意」和「內涵」。

60. 藝術終歸是藝術，真正好的藝術作品終會有揚眉吐氣的一天。那些原創性不足、品質低劣、只靠炒作或地域性情感因素哄抬的作品，只能風光一時，無法維持長久。任何人為因素都是一時的，只會曇花一現，經不起時間的考驗。

61. 一幅好的藝術作品，必須成為觀賞者所呼吸的清新空氣，這樣的作品才有生命可言。

62. 畫「大畫」不易，作「小畫」亦難。畫「大畫」不是像照片般放大擴張，它必須有足以支撐大畫面的架構及內容，需有深厚的技法基礎以及藝術修養，才能畫出氣勢磅礴、如交響樂般令人震撼的巨幅大作。畫大

畫切忌犯「大而不當」，而「大」未必等於「好」。波洛克的巨幅抽象畫，正因為有了上述的前提，才有撼動觀者的美感力量。小畫則是在方寸之地舖設錦繡大世界。精美的小畫，若看起來仍有「大畫」的感覺和氣勢，才算得上是好畫。克利的小畫就是這樣，尺幅之內卻蘊藏著天文數字的豐富性，非常耐看。

【肆】我說我畫

63. 我的作品一幅幅都用色彩表現出生命在大自然中的躍動和歡愉。

64. 我的每幅畫都是在不斷冥想的過程中隨機完成的。米開朗基羅對著大石頭冥想，待看到石頭中的激動，他才開始動刀。我在動筆前，像日本茶道那樣靜靜坐在畫布前，凝視著空白的畫布，冥想出意境，再由意境構想出造形和色彩。這時嘴裡念念有詞說：「啊！我要這樣畫！」立即動筆，急切地把那藏匿的內在經驗投射到畫布上。所以我在空白畫布前冥想的時間，有時會超過實際作畫的時間。

65. 我認為中國的文字是世界上最美的文字，尤其是狂草，本身有流動性、韻律感、節奏感，於是我用它來作為繪畫的基本元素。

66. 中國的文字本身具有音樂性，而且文字與文字之間也有音樂性，尤其是唐朝的狂草更具音樂性，它可成為藝術創作的新元素。

67. 色彩和線條在我的繪畫中一直扮演著重要的角色。我不單把二者從描述的功能中完全解放出來，發揮其固有功能，使其回復到最純粹、最簡單的繪畫形式；並將它的單純化和純粹化推向頂峰。這樣作品才會如同音樂一般的純粹，具有很高的精神性。

68. 繪畫是色彩的遊戲，也是心靈的遊戲。

69. 我一直認為色彩本身就能產生形象與主題，而空間也可藉著色彩來建立。所以，色彩在我的作品中的確擔當很重要的角色。我也一直努力把色彩的純粹化、單純化推向頂峰。

70. 我從本質藝術（essential art），即從色彩、造型出發，讓色彩成為觀者與畫家間視覺與精神的橋樑，讓觀者能跨越門檻，進入那五彩繽紛、燦爛奪目的世界，並把繪畫提昇到精神層面。康定斯基說過，抽象畫就是色彩與形象的一種安排與組合，所以如果能夠從本質藝術出發的話，那麼色彩與形象可以發揮得更生動、更完美。

71. 我畫畫從來不打草稿，一向採取「自然生育」的方式。我直接把顏料潑灑在畫布上，把內在生命與情感直接訴諸作畫行動，就像女人的「自然生育」一樣，不是「剖腹生產」。如此，畫家內在的生命與情感才不會被減弱或歪曲，而產生了不自然的「人工生育」。我認為，若透過草圖小心翼翼地作畫，難免會減弱內在的生命力。

72. 我是基於對大自然深切的體驗和冥想來創作的。自然中那恢宏的大氣、光輝絢爛的色彩，給了我無窮的天啟與靈感。

73. 我始終忠實於自我的內在世界，堅持抽象藝術的表現形式，因為它是最純粹的繪畫表現形式，所以我絕不會妥協或變節。

74. 我創作得之於苦心「創作」的少，而出於深刻「思考」的多。

75. 我使用油彩、壓克力彩或複合媒材作畫，都無法像畫水彩或水墨般，當天快速完成。為了突破與創新，幾乎每一幅畫畫完後我都會將其留在原處，每天以不同的角度反覆審視。所以每一幅畫都需要修改多次，不斷思考、斟酌、推敲，往往要數月甚或半年才可完成。畫畫真是「慢工出細活」啊！

【伍】抽象畫

76. 寫實畫就如譜上唱詞的歌，美則美矣，然意境有限，雙重限制了創作者和接受者的想像力。抽象畫則若無詞的樂曲，乃是一首色彩交響樂，涵蓋著無限豐富的生命。意境猶如不斷膨脹著的宇宙，無論創作者和接受者，都可駕馭著想像乘風而去，它是「視覺的音樂」。

77. 抽象繪畫旨在喚醒埋藏在生命最深邃處的美或情感。

78. 抽象藝術之創作，只有出於內在感情的強烈需要，才會真誠動人。這內在需要又與現實生活中的體驗密不可分。

79. 人生是不自由的，但是抽象藝術能給心靈以「接受美學」上的審美自由，能給人一種天馬行空的境界。

80. 我始終不渝地忠實於自我的內在世界，終生不懈地堅持抽象藝術的表現形式，因為它是最純粹的繪畫表現形式。我將與她「在天願作比翼鳥，在地願為連理枝」。

81. 詩是無形的抽象畫，而抽象畫是無聲的詩、空間的詩。

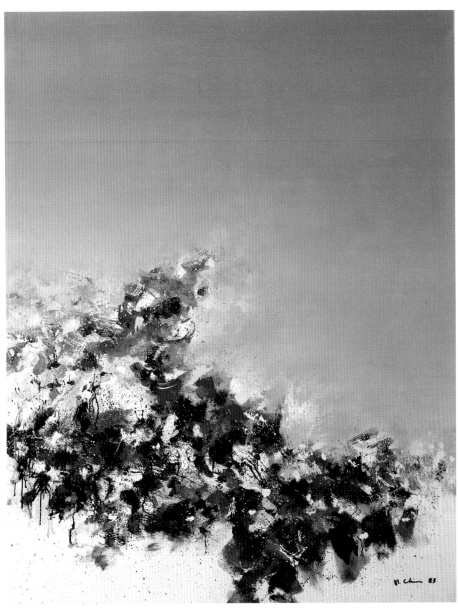

《海舞系列》，1983，油彩、畫布，112×145.5公分
SEA DANCE SERIES, 1983, oil on canvas, 112×145.5cm

82. 提昇欣賞抽象畫能力的良方，是營造學習欣賞抽象畫的生活環境。在家中或辦公室裡掛上幾幅優質的抽象畫，和它們生活在一起、工作在一起，營造耳濡目染的審美氛圍。易言之，就是要浸淫在抽象畫的環境裡，這將有助於提升美感品味與對現代藝術的邏輯思考力。從熟悉中體會抽象畫的內涵，不失為了解和欣賞抽象畫的良方。這就如同在家裡經常聽古典音樂一般，能培養對音樂美感的感受力。

83. 抽象畫不是能不能欣賞的問題，而是在於自己肯不肯突破陳舊的觀念，多花時間，多下功夫去學習和研究，並以真誠的態度去接近它。

84. 上個世紀末開始，人類進入數位時代。這以「0」與「1」兩個最簡單數字元素所建構的虛擬空間，改變了整個人類的生活方式。人們通過網際網路來到一個信息浩渺的無垠空間，我強烈地想要以繪畫來表現這個觸摸不到的神奇空間。我想這抽象的三度空間，唯有以表達內在經驗為訴求的抽象繪畫，才能靈動變現。

85. 抽象畫的定義和精神一直被一些人誤讀、誤解並誤導，以致在海峽兩岸有所謂「抽象山水」一詞。既然前面冠以「抽象」，其形象必然是「無法辨認」、「無可名狀」的，怎麼還會清清楚楚辨認出「山水」呢？這顯然是不合邏輯的。在海峽兩岸，因為對抽象理論的不求甚解，「抽象繪畫」一詞經常被曲解和濫用。

86. 有人認為「抽象畫」的觀念與精神中國古已有之，甚至還說在中國美術史上綿延了三千年之久。事實上，中國美術在古老的「中庸」和「中和」的哲學精神指引下，從來就沒有真正臻於純粹或完全抽象的境界，總是在「具象」與「抽象」之間游移徘徊。我們從唐朝水墨畫家張彥遠

的「夫畫最忌形貌采章」，以及北宋蘇東坡的「繪畫以形似，見與兒童鄰」等的繪畫思想，即可看出當時水墨畫家停滯（或游走）於「具象」與「抽象」之間。

87. 廿世紀初誕生的抽象畫，其觀念和精神內涵，與中國史前時期的彩陶和三千年前的商周銅器上的抽象「紋樣」截然不同。蓋中國史前時期的彩陶和商周時期的銅器圖案紋飾雖然都是抽象形式的紋樣，但這些紋樣均屬「裝飾藝術」的範疇，而非「造形藝術」的範疇，這是二者本質上與功能上的最大不同。蓋裝飾藝術的創作基本上是重「實用」和「裝飾」功能，且都無落款；而廿世紀誕生的抽象畫是由繪畫基本元素、形、色、線、空間等所構成和組合，它講究視覺元素間的複雜組合關係，其創作源於藝術家「內在需要」，並傳達其內在經驗的真相及探索內在世界的奧秘。因此，二者不可混淆。

88. 色彩是朝向抽象發展的一個重要課題。要往抽象的大道邁進，只有兩條路可以走。一是從色彩出發，一是從形象出發。康定斯基、德勞奈、庫普卡是從色彩出發抵達抽象藝術新天地的；而蒙德里安、馬勒維奇等則是從形象之路登上了抽象藝術群山的又一峰。

89. 回顧台灣抽象繪畫創作的世紀跑道上，有半路換跑道的、有落荒當逃兵的，大有人在。我想，或許是因創作艱辛，而又曲高和寡、知音難覓，最終因畫作得不到收藏家之青睞而難以維生吧！

90. 我把推展抽象藝術當成一種美的信仰的傳播！因此，我以傳教士般的熱忱在海峽兩岸傳播抽象藝術，以抽象藝術的傳道者為己任，努力讓自己成為「美的推手」。

【陸】中西藝術

91. 國畫與西畫，其媒材、工具、美學意趣都不同，科學哲學指出，不同規範不可比優劣。因此，二者萬不可楚河漢界，相互藐視，應該相互吸收其長處，將中西畫的特色加以融合。控制論鼻祖維納說，兩個不同學科的交接部往往是一門新學科的產床；那麼，國畫與西畫的交融，也可期待一種新藝術的誕生。

92. 中國首次大量吸收異質文化（alien culture，即外來文化）是南北朝時代。那時東北有契丹，南有印度，西有吐谷渾、波斯甚至羅馬帝國。因此，中國藝術不斷演變，累積到大唐而絢爛釋放。

93. 現代藝術已推翻優美的古典標準，故中國藝術家面對整個世界藝術潮流，要以開闊的胸襟去吸取異質文化的精華與養分，並與本國文化融合。這樣，才能創造一種更寬闊、更深遠、頗具異趣的作品，這本是「有容乃大」的中國文化之特性。作為一個現代藝術家，光從前人的藝術作品中汲取一些技巧與經驗是不夠的，除此之外，還需汲取異質文化。所謂異質文化即完全不同的外來文化，對於西方畫家來說，外來文化包括中國書法、日本浮世繪畫、東方木刻版畫、禪畫、台灣原住民藝術、非洲及大洋洲之木雕藝術、心智殘障者及兒童的繪畫…等，藝術家由此獲取開創新流派的靈感與啟示。例如畢卡索從非洲黑人原始雕刻獲取靈感，而在造形上產生重大的突破。梵谷則從日本浮世繪畫獲取啟示，他的色彩變得更為明朗，並發展出書法的線條。而抽象大師哈同、蘇拉奇以及克來恩等人均從東方書法中獲得靈感與啟示，產生富有韻律與節奏感的書法抽象風格。

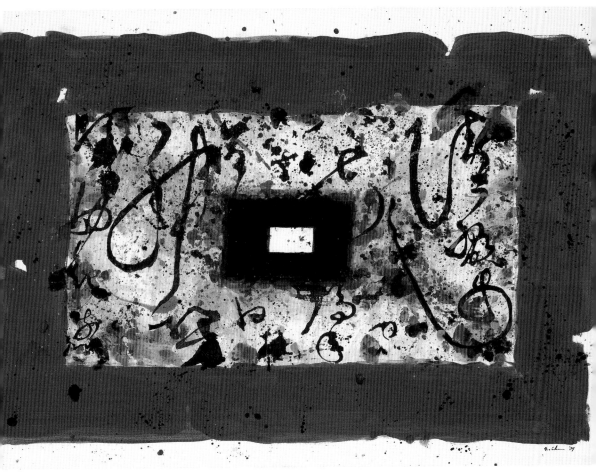

《窗系列》，2009，複合媒材、畫布，112×162公分
WINDOW Series, 2009, mixed media on canvas, 112×162cm

94. 對藝術創作的長期投入與專注，對民族傳統藝術的深刻了解，並從中吸收養分，以寬大的胸懷汲取異質文化的精華，融會貫通，將有助於自我風格的建立。

95. 有人說：「現代人創作的繪畫，就是現代畫。」這種說法就好像「中國人畫的畫，就是中國畫」一樣不合邏輯。因為有些現代人的創作觀念還停留在十八、十九世紀，有些中國人畫的畫，像西方人畫的畫。我國現代藝術至今尚未走出模仿西方人的侷限，即使是中國人畫的，也僅摻入些許東方技法或地域色彩，仍全盤採納西方藝術的技巧和觀念，因此，看起來都「似曾相識燕歸來」。

96. 西風可借，但仍需奠定東風的基礎，唯有闊大的東風基礎才有足夠兼容西風的潛能。中國藝術家必須懂得挖掘中國傳統文化與藝術的內涵，在「借西風」的過程中將其轉化成現代視覺語言，創造出富有東方特色的視覺藝術，這是中國藝術創新和走向世界的一條廣闊大道。

97. 結合西方的表現工具和形式，或吸取西方經驗才是中國水墨畫發展的唯一途徑。中國水墨畫是中國獨特的藝術，它是以筆墨的情趣和意境來展現我國儒家、道家以及佛教的思想。但自宋元以來，即以師承和臨摹為風尚，往往拘泥於中國傳統水墨的技法。今天大部分的中國繪畫之所以如此貧血，會走進死巷，是大部分畫家閉關自守，因循守舊，而不敢放膽創新，痼疾是缺乏多方面的文化營養。其解決之道，可與西方的技法合璧，跳脫摹擬，走向創新。

98. 對於一個中國的現代藝術家來說，在創作素材和技巧上，可以不完全屬於中國，但在精神上卻是必須回歸於自己的傳統。因為傳統是一項豐富

的資產，一個藝術家絕不能忘卻本身的傳統，不過也不能以只做地域性藝術家為滿足，應以發展成一個國際性藝術家為職志。

99. 東方人要成為國際藝術家，應該把東方人傳統的美以及文化中對美的意識完全表現出來，才能找到真正的自我。若找不到自己的歸屬和定位，國外藝術家也不會認同我們。因此，我一生都在努力尋找「東方與西方的交融－meeting」。

100. 現代藝術家應該有「立足本土，放眼國際」的眼光和胸襟，不要只滿足於目前在國內的成就，應該走出去，與國際藝術界交流，相互砥礪觀摩。畫家像球隊一樣，需要經常參加國際性大展，與其他國家的藝術家比較，才知自己的實力；否則，如井底蛙，不知天高地厚。問題是參加國際展談何容易，通常須經過國際評審團或策展人之邀請，才能獲邀參展。

101. 廿一世紀是東西方藝術文化融合的大時代。未來的世界藝術中，中國藝術將是很重要的一部分，國際藝壇將看好華人藝術家未來的表現。華人藝術家只有抱持「有容乃大」的中國文化特性, 對東西方文化深入研究及了解，才能把二者融合起來，創作出現代的中國藝術。這樣，一定會對世界藝術文化的發展有所貢獻，而為全人類所肯定，此一理想也是我對自己未來的期許。

【柒】藝術教育

102. 要成為一個藝術家，不是只依托學校教育。畢業後必須建立自己的藝術觀，努力走自己的路。老師只是藝術教育者、一位引路人或啟蒙者而已，不是萬能藝術家，美術教育不是培養現在最流行的美術。如果學生

只學了老師這一道菜，五年、十年之後，他們就不知所措。譬如說吧，目前裝置藝術風行全台，美術館也經常舉辦，但裝置藝術在美國早已開始式微了，那學校還要不要再教裝置藝術呢？所以，學校裡的課程要有現代規畫。不是教會學生某種新流派，而是讓學生受到現代藝術觀念、技法與原創意識的訓練；換句話說，不是給學生一隻鳥，而是給一把能打鳥的槍，這就是教師與做一個藝術家的不同之處。

103. 美術院校的學生，每人畫出的東西都差不多，缺乏個性。而老師的主要工作不是糾正學生的技巧，而是應該透過討論，幫助學生尋找自己的繪畫語言。

104. 藝術家一定要能獨立思考，有能力建構自己的思想，但我們的美術教育太過保守與嚴苛，無法給學生足夠的空間讓學生成長發揮，所以我們的美術教育有時會成為阻礙。

105. 在學校課堂裡學習的知識與技法，不論教材與教法，仍顯得保守，缺少啟發性和創造性，依樣畫葫蘆，很多已經過時，甚至是錯誤的。長期以來，教授美術的課程已經僵化，因此，須要更新教學課程，這樣可縮小教學大綱與最新藝術發展之間的差距。至於社會美術教育方面反倒是比較成功的，儘管其規模是零散的，聲音也不大，但影響力卻是深遠的。

106. 一般老師所教的都是那個時代的想法和技法，等到學生學會時已嫌老舊落伍了。因此，學生們應該超越老師，做和老師不一樣的事。

陈正雄画语录

序

语录中的智慧
——陈正雄的艺术思维与创见

 在战后台湾美术史上，陈正雄（1935-）是颇为特殊的一个案例：在看似非专业学院训练出身的背景下，却成为台湾抽象艺术最具专业理解与强力创作成果的一位成功画家。陈正雄不仅在1991年就已经和赵无极（1921-2013）、朱德群（1920-）同时成为巴黎五月沙龙的少数受邀华人画家之一，更是意大利佛罗伦萨国际当代艺术双年展最高荣誉——「终生艺术成就奖」及「伟大的罗伦佐金章」1999年及2001年连续两届的得主，为亚州裔第一人。十余年来，更多次深入中国内地，以传者般的热情，受邀为许许多多的专业美术学院，包括：北京清华大学、北京大学、中央美院、中国艺术研究院、北京人民大学、宋庄美术馆、今日美术馆、杭州中国美院、四川美院、四川大学、四川师大、成都美院、鲁迅美院、南京艺术学院、上海复旦大学、华东师大、交通大学、上海大学、上海师大、上海设计学院、上海东华大学、辽宁师大……等名校讲解、介绍抽象艺术的思潮与作品；同时也是1994年上海美术馆的咨询委员及上海美术双年展的策划人，可以说是近年来中国画坛接触抽象艺术最重要的理论指导者之一。

陈正雄在就读台北建国中学高中一年级时，曾受业于台湾第一代艺术大师李石樵及金润作，并从他们身上获得许多艺术方面的知识与见解。不过，陈正雄对艺术的学习，更重要的是来自自我不懈的学习。由于英日文能力的精湛，他在大学时期，便已读完英文版的抽象艺术经典名著，也就是康丁斯基的《艺术的精神性》；毕业后，服预官役受训练期间，又大量研读英国艺评家赫伯特‧里德的《现代绘画简史》和《现代艺术哲学》等书。可以说：在初踏上创作的时期，陈正雄对现代艺术的认知，便已经从前辈画家的基础出发，进而超越了第一代油画家的思维。

　　1960年代，台湾的现代绘画运动正逢启蒙出发的时刻，许多对现代主义，乃至抽象绘画的介绍，都是片面且可能误解的转手信息；陈正雄便以他来自原典研读的知识，在1965年年中，假《文星》（92期）发表〈谈抽象艺术〉一文，深入浅出地从历史发展的脉络及艺术理论的角度，为「抽象艺术」的本质提出深具学术性的诠释与介绍。在这篇先期性的介绍文字中，他写道：

　　　　在我们尚未了解抽象艺术之前，首先要明白一点，与其说抽象艺术的特质是描写的（Descriptive），不如说是召唤的（Evocative）。它就如同音乐一样，旨在激发内在情感，而非述说故事。它系艺术家内在经验（情绪、心情或情感等）的一种强烈表征，是一种视觉的隐喻（Visual Metaphor）而非视觉的叙述（Visual Narrative）。

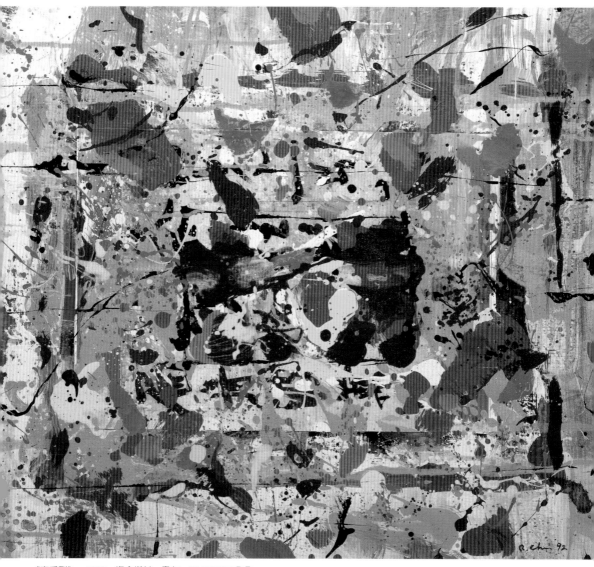

《窗系列》，1992，複合媒材、畫布，60.5×72.5公分
WINDOW SERIES, 1992, mixed media on canvas, 60.5×72.5cm

艺术作品系激发人们内在经验的一种工具，这是了解抽象艺术所必须具备的基本概念。就心理学来说，这种概念系由共同联想（Common Association）与移情作用（Empathy）两者所发生的。「共同联想」系指由于自然形象或事物与色彩、形状、线条之间的关系共同连结而产生了一种特别感觉及概念的过程。举例来说，红色似乎往往意指着炙热或者兴奋；黄色表示太阳与愉快；蓝与黑则代表冷静与忧郁；生物形则表示生命，几何形则反映理智的构成；地平线则表静息；对角线则表示行动；而直角则表示稳定。

「移情作用」则指人类的想象与外界物体或生物密切联结的能力而言。就艺术而言，它系指感受梵谷笔下的热情、马蒂斯轮廓的优美、孟德里安（Piet Mondrian）或布兰克西（Constantin Brancusi）作品的严谨，或者感受罗斯科（Mark Rothko）色彩的宁静能力而言。

在一件含有许多绘画要素与综合关系的艺术作品里，其表现的情感是异常丰富而神妙不可思议的。但这并非所有艺术家均能利用他们的才智去作有意识的安排，以组成这种复杂的关系来传达一种特有的情绪或心情。其发生的过程往往是不知不觉而且是潜在意识的。大多数的现代艺术家只觉得需要传达他们自己内在的情感而根本无意于记录他们的视觉。真正伟大的艺术家，对于某种经验特具敏感，并且能把他的内在经验综合起来，强烈地表现在他的艺术作品中。举例来说，大多数的人只能看见法国南部乡村的肤浅外表，但塞尚则能看出自然中的逻辑组织与统一；雷诺瓦则发现愉快的美感；梵谷则显示挣扎与狂热。故每一位艺术家的独有特质与内在经验的强烈能给予他的艺术真正的意义。

1964年，陈正雄以《柠檬》一作，获得「台湾省全省美术展览会」油画部第三名的荣誉，展开他此后长期的专业创作生涯，也成为台湾战后少数能完全以艺术创作作为专业的成功画家之一；但他始终保持以文字论述推动、导正抽象艺术发展的热诚。在此后的日子中，他先后撰就的相关文字，最具代表性者，如：1965年的〈风靡欧美的欧普艺术〉（1965.5.2《征信新闻》），1967年的〈战后国际艺坛动向〉（1967.6.3《中央日报》）、〈漫谈抽象艺术〉（1967.7.24《台湾新生报》）〈抽象艺术是什么？〉（1968.7《雄狮月刊》），以及1968年为知名《东方杂志》撰写的〈抒情抽象与几何抽象〉（复刊第1卷第9期）、〈抽象艺术之先驱——立体派与未来派〉（复刊第2卷第6期）、〈谈纽约画派〉（复刊第3卷第12期）等。1980年代，也为甫成立的台北市立美术馆馆刊《现代美术》撰写〈20世纪抽象艺术的精神〉（58期），及为《自立晚报》撰写〈新空间观念的探讨〉（1985.7.10）。到了1990年代后期，出面抢救几临流产的「法国当代艺术大展」，又撰〈哈同的抒情抽象与东方书法〉（1997.4.27《自立晚报》）一文。隔年（1998），朱德群「远东巡回画展」第一站在北京中国美术馆揭幕，陈正雄恰巧人在北京，躬逢其盛，特为老友再撰〈曙光与朦胧——论朱德群的抽象绘画〉（1998.7.23《自立晚报》）为之推介。在此前后也为中国大陆美术期刊先后撰写〈从具象到抽象〉（1994.6《艺术世界》）、〈抽象画欣赏的美学原则〉（2009.7.10《中国艺术报》）。

　　事实上，自1970年代以来，陈正雄的艺术足迹，遍及欧洲的巴黎、意大利、美国的纽约、旧金山、夏威夷、亚洲的日本等地，也

会晤了许多世界知名的当代艺术大师，如：法国的彼尔·阿雷辛斯基（Piere Alechinsky）、马塔（Roberto S. Matta）、柯奈荷（Willem Corneille）、德培（Olivier Debre），美国的山姆·弗朗西斯（Sam Francis）、卡雷尔·阿贝鲁（Karel Appel）、日本的菅井汲、池田满寿夫，以及知名艺评家和艺术史家如：英国牛津大学的苏立文（Michael Sullivan）、美国的约翰·史帕克（John T. Spike）、法国的龙柏（Jean-Clarence Lambert）、杰拉·苏瑞哈（Gerard Xurigera）、意大利的彼尔·雷斯塔尼（Pierre Restany）、日本的植村鹰千代……等。陈正雄与这些当代艺术巨擘互相交流彼此的创作经验与美学观，更厚植了他们大师之间的友谊。陈正雄将累积数十年来难能可贵的心得以《陈正雄画语录》为名结集出书，成为台湾画家的第一本画语录。这是画家学习、思索、创作艺术的思维记录，对艺术家个人而言，是一种学理的整理与呈现，对关怀、学习艺术，尤其是抽象艺术的同好或后辈而言，则是一项极佳的引导与启蒙。

全书计分七个大项，分别是：
（一）艺术理念
（二）艺术家
（三）艺术作品
（四）我说我画
（五）抽象画
（六）中西艺术
（七）艺术教育

在每个大项中，都收录20至30条左右的语录，每一语录的字数，短则1～20字，长则不过百余字，简明扼要，且充满启发性。如「艺术理念」乙项中，开宗明义，即谓：「艺术不在表现第一层面的经验，而在表现第二层面的真实。因为这深层的真实，更纯粹、更直指人性。」直探艺术本质的核心，对那些终日以描绘物象表面为目标的「画家」，予以直接的棒喝。

又谓：「我的艺术旨在探索和传达我所确信的唯一真实——即内在经验（感情、情绪、心情）的真相，并藉助绘画的基本元素和美感形式，探寻内在世界的奥秘，将不可见的内在经验化为可见的视觉存在。」

有人认为：艺术没有绝对的定义。这话或许真确，但艺术如果没有了内在经验的探寻与呈现，徒然落入固定技巧的搬演，艺术也就不可能在人类的文明中扮演如此重要的角色。此外，或许艺术可以有多元的见解或定义，但就一个严肃的艺术家而言，其见解或定义，必形成一种完整的体系，不至纷乱乃至矛盾。

陈正雄的画语录，就是陈正雄的艺术见解与定义，同时也是二十世纪抽象艺术的主流思想与定义。固然，抽象不是艺术唯一的形式标准，但由抽象引导、开展的各种艺术见解与视野，却是人类在二十世纪最伟大的文明成就之一。陈正雄立基于这个人类共同的文明基础，发展出自我艺术的思想体系，有些或许是个人的，但绝大部份则是人类足可共享的经验与方向。比如他在「艺术家」乙项中，有谓：「『风格』是表达画家个人特性和思想的一种方式，是画家的标志，

它能使作品带有明显的个人色彩。一个艺术家建立自己绘画的风格，也就是有了自己的绘画语言，有了自己独特的面貌。从这个角度来看，一位优秀的画家同时也将是一位绘画语言艺术家。」又谓：「建立自己的风格难，突破或颠覆已建立的风格更难。艺术家最艰难的工作在于如何不断地超越自己，寻求突破、颠覆，并不断地以新面貌展现自己的艺术内涵。一个艺术家的创作风格停止变化，不能突破，就意味着艺术生命的死亡。」这样的见解，不论是对抽象或具象风格的艺术家而言，都是不移的真理。

针对「艺术作品」，他也有对「非创作者」的一些忠告，如：「买画是对专业画家最大的鼓励，也是对『造美产业』最实质的赞助，它是支持专业画家不断工作的工具。创作者有了各方的鼓励，才能持续专心致力于创作。」又说：「富豪们经常一掷万金，购买名家的名画，其中有一部份人的确是基于艺术兴趣与品味。但也有不少人常常是为了投资生财、免税节税、附庸风雅或博得慈善美名，尽管原因不一而足，无非希望能为铜臭的外表喷上一点艺术香水，亦即把『铜臭味』变成『铜香味』。尽管如此，社会上的艺术风气和水准会随着蓬勃提升起来，这也就是著名经济学家亚当．史密斯所说的『看不见的手』。」至于对创作者，他也建议：「画『大画』不易，作『小画』亦难。画『大画』不是像照片般放大扩张，它必须有足以支撑大画面的架构及内容，需有深厚的技法基础以及艺术修养，才能画出气势磅礴、如交响乐般令人震撼的巨幅大作。画大画切忌犯『大而不当』，而『大』未必等于『好』。波洛克的巨幅抽象画，正因为有了上述的前提，才有撼动观者的美感力量。小画则是在方寸之地铺设

锦绣大世界。精美的小画，若看起来仍有『大画』的感觉和气势，才算得上是好画。克利的小画就是这样，尺幅之内却蕴藏着天文数字的丰富性，非常耐看。」

对「抽象画」这一主题，也是全书相当精华的一个部份。很多人常有「看不懂抽象画」的困扰，陈正雄也以简明易懂的语言加以阐述。他说：「写实画就如谱上唱词的歌，美则美矣，然意境有限，双重限制了创作者和接受者的想象力。抽象画则若无词的乐曲，乃是一首色彩交响乐，涵盖着无限丰富的生命。意境犹如不断膨胀着的宇宙，无论创作者和接受者，都可驾驭着想象乘风而去，它是『视觉的音乐』。」又说：「人生是不自由的，但是抽象艺术能给心灵以『接受美学』上的审美自由，能给人一种天马行空的境界。」因此他建议：「提升欣赏抽象画能力的良方，是营造学习欣赏抽象画的生活环境。在家中或办公室里挂上几幅优质的抽象画，和它们生活在一起、工作在一起，营造耳濡目染的审美氛围。易言之，就是要浸淫在抽象画的环境里，这将有助于提升美感品味与对现代艺术的逻辑思考力。从熟悉中体会抽象画的内涵，不失为了解和欣赏抽象画的良方。这就如同在家里经常听古典音乐一般，能培养对音乐美感的感受力。」

对于部份将抽象绘画比喻为「中国古已有之」的说法，陈正雄也导正说：「有人认为『抽象画』的观念与精神中国古已有之，甚至还说在中国美术史上绵延了三千年之久。事实上，中国美术在古老的『中庸』和『中和』的哲学精神指引下，从来就没有真正臻于纯粹或完全抽象的境界，总是在『具象』与『抽象』之间游移徘徊。我们从唐朝水墨画家张彦远的『夫画最忌形貌采章』，以及北宋苏东坡的

『绘画以形似，见与儿童邻』等的绘画思想，即可看出当时水墨画家停滞（或游走）于『具象』与『抽象』之间。」他更进一步解释说：「廿世纪初诞生的抽象画，其观念和精神内涵，与中国史前时期的彩陶和三千年前的商周铜器上的抽象『纹样』截然不同。盖中国史前时期的彩陶和商周时期的铜器图案纹饰虽然都是抽象形式的纹样，但这些纹样均属『装饰艺术』的范畴，而非『造形艺术』的范畴，这是二者本质上与功能上的最大不同。盖装饰艺术的创作基本上是重『实用』和『装饰』功能，且都无落款；而廿世纪诞生的抽象画是由绘画基本元素、形、色、线、空间等所构成和组合，它讲究视觉元素间的复杂组合关系，其创作源于艺术家『内在需要』，并传达其内在经验的真相及探索内在世界的奥秘。因此，二者不可混淆。」

对于「中西艺术」的比较，陈正雄也有颇为精辟的看法，他认为：「国画与西画，其媒材、工具、美学意趣都不同，科学哲学指出，不同规范不可比优劣。因此，二者万不可楚河汉界，相互藐视，应该相互吸收其长处，将中西画的特色加以融合。控制论鼻祖维纳说，两个不同学科的交接部往往是一门新学科的产床；那么，国画与西画的交缘，也可期待一种新艺术的诞生。」因此，他主张：「结合西方的表现工具和形式，或吸取西方经验才是中国水墨画发展的唯一途径。中国水墨画是中国独特的艺术，它是以笔墨的情趣和意境来展现我国儒家、道家以及佛教的思想。但自宋元以来，即以师承和临摹为风尚，往往拘泥于中国传统水墨的技法。今天大部分的中国绘画之所以如此贫血，会走进死巷，是大部分画家闭关自守，因循守旧，而不敢放胆创新，痼疾是缺乏多方面的文化营养。其解决之道，可与西方的技

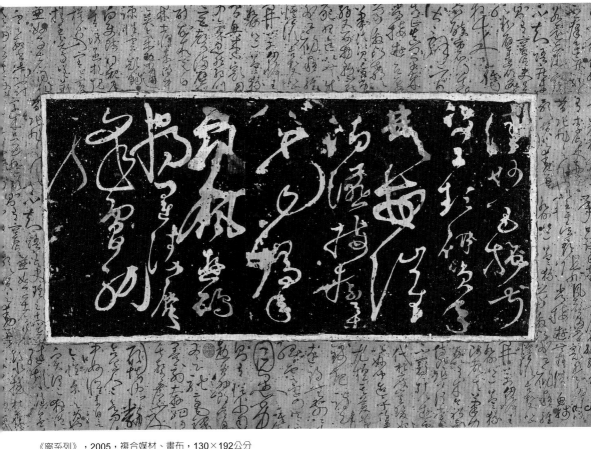

《窗系列》，2005，複合媒材、畫布，130×192公分
WINDOW SERIES, 2005, mixed media on canvas, 130×192c

法合璧，跳脱摹拟，走向创新。」

在纯粹的艺术创作之外，他也关心「艺术教育」；对「艺术教育」的实施，有一套独特的看法。他认为：「在学校课堂里学习的知识与技法，不论教材与教法，仍显得保守，缺少启发性和创造性，依样画葫芦，很多已经过时，甚至是错误的。长期以来，教授美术的课程已经僵化，因此，须要更新教学课程，这样可缩小教学大纲与最新艺术发展之间的差距。至于社会美术教育方面反倒是比较成功的，尽管其规模是零散的，声音也不大，但影响力却是深远的。」因此他主张：「要成为一个艺术家，不是只依托学校教育。毕业后必须建立自己的艺术观，努力走自己的路。老师只是艺术教育者、一位引路人或启蒙者而已，不是万能艺术家，美术教育不是培养现在最流行的美术。如果学生只学了老师这一道菜，五年、十年之后，他们就不知所措。譬如说吧，目前装置艺术风行全台，美术馆也经常举办，但装置艺术在美国早已开始式微了，那学校还要不要再教装置艺术呢？所以，学校里的课程要有现代规画。不是教会学生某种新流派，而是让学生受到现代艺术观念、技法与原创意识的训练；换句话说，不是给学生一只鸟，而是给一把能打鸟的枪，这就是教师与做一个艺术家的不同之处。」

对于自己的创作，他在「我说我画」项下，指出：「我的作品一幅幅都用色彩表现出生命在大自然中的跃动和欢愉。」他说：「我的每幅画都是在不断冥想的过程中随机完成的。米开朗基罗对着大石头冥想，待看到石头中的激动，他才开始动刀。我在动笔前，像日本茶道那样静静坐在画布前，凝视着空白的画布，冥想出意境，再由意境

构想出造形和色彩。这时嘴里念念有词说：『啊！我要这样画！』立即动笔，急切地把那藏匿的内在经验投射到画布上。所以我在空白画布前冥想的时间，有时会超过实际作画的时间。」他解释：「我画画从来不打草稿，一向采取『自然生育』的方式。我直接把颜料泼洒在画布上，把内在生命与情感直接诉诸作画行动，就像女人的『自然生育』一样，不是『剖腹生产』。如此，画家内在的生命与情感才不会被减弱或歪曲，而产生了不自然的『人工生育』。我认为，若透过草图小心翼翼地作画，难免会减弱内在的生命力。」因此，他总结自己的创作说：「我从本质艺术（essential art），即从色彩、造型出发，让色彩成为观者与画家间视觉与精神的桥梁，让观者能跨越门坎，进入那五彩缤纷、灿烂夺目的世界，并把绘画提升到精神层面。康定斯基说过，抽象画就是色彩与形象的一种安排与组合，所以如果能够从本质艺术出发的话，那么色彩与形象可以发挥得更生动、更完美。」

总之，这些看似琐碎独立的语录，其实有着艺术家长期思考、实践的心得与经验为基础，形成了一个完整的思想体系，称之为「陈正雄的艺术观」或「陈正雄的艺术思想体系」，亦非过语。其中，有许多带着现代科学思维的说法，尤具独创性和启发性；如论及「艺术理念」时，他以现代生物基因学的理念，提出：「艺术的创作颇像生物科技的基因工程。生物要产生新的品种，必须引入新的基因组接出新的基因链。创作也一样，希望有新的风格、新的形式、新的内容出现，就必须要有新的艺术基因来组接。颠覆与重建，可说是现代艺术的基因工程。我个人就是用所谓『现代绘画基因工程』的观念来重建与突破的。对我而言，每次的突破、颠覆意味着更多、更大的挑战与

冒险；而不突破、不颠覆则是更大的不安与痛苦」又说：「艺术家需要建构自己的艺术基因库，懂得从异质文化的艺术宝库中寻找新颖的艺术基因，加以萃取后，以创造新物种的方法，创作出无疆界的艺术作品来，这才是上上策。我从台湾原住民艺术中萃取了两种『基因』：强烈的色彩和鲜活的生命力，也从唐朝的狂草里萃取丰富的图像及音乐性，它给我的绘画引进了新的创造基因链，产生新种的艺术产品，所以我的绘画创作其实是一种绘画的基因工程。」因此，他认为：「文化的创造活力一如生物的基因重组，多元的文化基因，自能产生泉源活水般的创作生机和成果。因此对不同文化要多学习、多认识、多交流，并加以认同。『去文化』则是对创造力的杀戮。」这是相当有趣又具学理的说法。

另外，论及「抽象画」时，他也说：「上个世纪末开始，人类进入数字时代。这以『0』与『1』两个最简单数字元素所建构的虚空间，改变了整个人类的生活方式。人们通过因特网来到一个信息浩渺的无垠空间，我强烈地想要以绘画来表现这个触摸不到的神奇空间。我想这抽象的三度空间，唯有以表达内在经验为诉求的抽象绘画，才能灵动变现。」

艺术创作是一项艰巨的文化工程，每位创作者如何界定自己的定位，也影响到艺术家自我要求及自我努力的标准。陈正雄说：「如果把艺术创作的层次比喻成金字塔的话，大致上可概分为三个层次。金字塔的顶端是极其少数，能跨时代建立起新艺术价值观者，包括各主义画派的拓荒者与先驱者，如毕加索、马谛斯、康定斯基、杜象……

等人，他们像科学上的牛顿、爱因斯坦，不但建立了新的艺术价值观，开创艺术新视野，且其艺术观深深影响了以后的艺术发展，居功厥伟。第二个层次为已建立了自己风格的艺术家，他们能建立自己独特的艺术语言与面貌，已属不易，可算是相当成功的艺术家。如果他们能不断地突破既有之风格，并不断地以新面貌展现自己新的艺术内涵，则将更难能可贵了。底层则为绝大多数未能建立自我风格的一般画家。」又说：「真正艺术家的创作并不在乎观者能否了解或欣赏。若画家为了迎合世俗，画一些迎合绘画市场导向的画作，虽然能卖画，解决画家生活的问题，但那只是出卖技巧而已。如此只会抹杀其艺术价值和前途。所以，艺术家要淡薄名利，视富贵如浮云，才能创作好的作品。真正有成就的艺术家都是专职创作的专业画家，他们均以创作为职业，并引以为荣。」显然陈正雄正是以这样的标准自我定位、自我要求，也不断努力。

作为一个专业的创作者，陈正雄始终勤于吸纳、研究，及笔耕。他既是台湾原住民艺术知名的收藏者与研究者，也是中国宫廷服饰的专家。而在现代艺术，尤其抽象绘画的论述上，他早在1991年，即为台湾省立美术馆（今国立台湾美术馆）撰写《抽象画》一书；隔年（1992），又着《抽象艺术的诞生与发展》一书，由台北市立美术馆出版。

这十多年来，他应邀前往中国大陆讲学四十馀次，也应北京清华大学艺术学院之邀，撰就《抽象艺术论》一书。如今《陈正雄画语录》的出版，让我们在严谨的学术论述之外，更贴近地深入这位杰出

艺术家的思维天地，不论是欣赏、创作、收藏，都是一本极佳的入门导论，值得人手一册，传阅八方。

萧琼瑞

2012年5月

（本文作者为台湾国立成功大学历史系所美术史教授）

序

康定斯基式的作风

1

我在巴黎采访国际著名抽象画家赵无极时，有过如下的对话。

我在赵无极的画室中指着他的一幅三联画问：「在这幅作品中，传达了您什么样的内在体验、感悟或者是观念？」

赵儒雅地一笑，答道：「哈，我要是说得出来就不画了。」

我被他友善地揶揄之后领悟：哦，画家是只画不说的，或者说画家是以画代说的。

然而，我走出画室一省思：未必。创立抽象主义绘画的开山祖师康定斯基（Wassily Kandinsky, 1866-1944）不是又画又「说」的大画家吗？他在任教于德国包浩斯学院时著书立说，出版了《艺术的精神性》、《回忆录》、《点、线、面》等著作。

我们就此作个思想实验。假定康定斯基当年只画不说，那么后人就完全无法真正明了他创立抽象绘画的原宗旨，只能做出种种莫衷一是、空耗智慧的猜想。由此，可能会认为他的作品不过是任意涂鸦，或者把写意画、装饰图案等误读为抽象画。倘若是这样，抽象主义概

念的内涵与外延将全是猜测而不能确定，那么抽象主义就在混沌中被混掉了。因此，康定斯基要画也要说。

陈正雄不仅在绘画上两度荣膺佛罗伦萨国际当代艺术双年展「终身艺术成就奖」，及「伟大的罗伦佐金章」，是亚州裔第一人，而且也出版论著《抽象画》（国立台湾美术馆）、《进入抽象艺术》（合着，台北市立美术馆）、《抽象艺术论》（北京清华大学出版社），现在还要出版这本《画语录》，成为台湾画家的第一本画语录。

无疑，这是康定斯基的作风。

2

陈正雄的《画语录》，用的是历史悠久的语录体文体。

这种文体早在人类「文明轴心时代」就盛行了，古希腊有《柏拉图对话录》，而中国孔子的弟子们也编撰了记录孔子语录的《论语》，历经几千年仍然弥新。究其原因，对于作者来说，能最大限度地自由表达，行文无挂无碍，思维跌宕跳跃，段落之间不受逻辑约束；对于读者来说，作者心灵中深奥的学理往往被化作灵动、易懂的感性语言来表达，因而读者的阅读量小而信息量大，还有着很强的被启动出创意思维的启动能。

陈正雄从事绘画一甲子，一边画画一边思索，一有中国佛教禅师似的顿悟，马上记录下来。他熟谙英语、日语，走遍世界，直接与世界正领风骚的画家同道们交友畅叙，在这般阅读他人大脑的最具活性的阅读中，常有火花被对撞出来，恐其稍纵即逝，立即记录到小本子上。他还是一位很受欢迎的「讲座教授」，常被世界各地的高等学

《窗系列》，2010，複合媒材、畫布，132×162公分
WINDOW SERIES, 2010, mixed media on canvas, 132×162cm

府请去讲座，思维新锐的学子们常常会在课堂上提出一些意想不到的「聪明的问题」（爱因斯坦语），陈正雄在回答之后赶快记录了下来。凡此种种，就锤炼成了这里的画语录106条。

汉语中常用「与君一席谈，胜读十年书」的成语来形容受益匪浅的谈话所得。在你读这本语录时，这个「胜读十年书」的历史记录被远远突破了。陈正雄思索了60年的彻悟，他只用了高度凝练的12000字表达，换句话说，读者你只需要用一个小时的阅读就能全收，那么，假定你的智商比作者高一倍，那你还胜读了30年书！何况，你比这位「台湾抽象画教父」更聪明还是个假定。

3

画语录是否只是画家写给画家看的文本呢？

台湾《联合报》是台湾乃至海外华人中最有影响的报纸之一。它的副刊——「联合副刊」——也是蜚声台湾艺术界与艺术爱好者的园地。这家副刊总编辑在阅读了陈正雄的画语录之后，破天荒地进行了连载，回响甚好。副刊的广大读者当然不都是画家，而是一个艺术、特别是文学的爱好者的大群体。获得这个艺术泛群体的青睐意味着什么？意味着陈正雄的画语录不是在讲述绘画技法，而是在讲述所有艺术创新乃至所有思维创新的通衢所在。

不妨信手拈来几条：

——创意作品是永远不死的；没有创意，作品未生即死。

《窗系列》，2011，複合媒材、畫布，130×162公分
WINDOW SERIES, 2011, mixed media on canvas, 130×162cm

——跟着前人的脚步走，或走别人走过的路，你将永远落后一步，永远扼杀自己的风格。新路是故意的落荒者走出来的，前面没有路，就自己开路。

——突破，应该是沿着艺术史轴线的「加法」，即要加进「更新颖而精致的形而下表达」、「更精深而契合潮流的形而上意义」，或者是「对世界崭新的感知方式」等等。

——创新的机理是自我颠覆，这等同于自残。无论是自我压迫，还是自残，都是自找的苦。因此德国大诗人歌德才会说，「艺术的根是苦的，因此其果实才会是甜的」。

——绘画艺术在为人类大众开拓新的视觉空间，这要合群。然而，真正的创新又是曲高和寡，疏离人群。一个要合群，一个是不得不离群，艺术家就在这二律背反中受罪。苦啊！这是艺术家的原罪！宿命的原罪！

读完以上引来的几条语录，就可知道它对一切创造者的普适性了。

因此，这本语录，画家读来可能会有「茅塞顿开」之感，非画家却崇尚创意的人们读后也会有「人同此心、心同此理」的共鸣与激荡。

4

从心灵里流出来的，才可能如山涧春溪般顺畅地泻流到他人的心田去。

陈正雄的画语录，正是从他积累了六十年内在真实经验的艺术心灵中汩汩流淌出来的……。

祖慰

2011年9月于巴黎

（本文作者为旅法作家、陈正雄传记《画布上的欢乐颂》作者、上海同济大学教授、2010年上海世博会世博局顾问）

陈正雄画语录

【壹】艺术理念

1. 艺术不在表现第一层面的经验，而在表现第二层面的真实。因为这深层的真实更纯粹、更直指人性。

2. 我的艺术旨在探索和传达我所确信的唯一真实——即内在经验（感情、情绪、心情）的真相，并藉助绘画的基本元素和美感形式，探寻内在世界的奥秘，将不可见的内在经验化为可见的视觉存在。

3. 我深信，一位真正的艺术家会对某些经验特具敏感，并且能把内在经验综合起来，强烈地表现在他的作品里。这时，他只知道传达其内在经验的真相，而对感官和知觉的记录一点也不感兴趣。

4. 我的艺术是「召唤的」，而非「描绘的」。如同音乐，旨在激发内在情感，而非记录自然的外貌或述说故事。它是内在经验的一种强烈表征，是视觉的「隐喻」，而非视觉的「叙述」。

5. 写实画家是画肉眼所见的现实世界，诚如亚里士多德所倡导的旨在「摹仿自然」，往往记录下自然或现实的皮相外貌。自从照相机发明以后，摄影家已将摹仿自然表现到了极致。现代画家若能在作品里传达观念或内在经验的真相，那将会更真实，更有意义，更能发现画家自己。

6. 艺术创作是一种直觉的冲动。画家是藉助基本绘画元素，将其表现或传
达出来。通常，艺术理论均是在新创作出现之后经过数年归纳演绎才产
生的；也就依说，先有「艺术作品」，然后才有「艺术理论」。所以，
艺术理论是后起的，不领导创作的。二者具有相辅相成的关系，而理论
则扮演辅佐的角色。

7 现代艺术都是由观念主导创作。艺术家倘若没有独特的观念，只是「空
白」创作的话，作品会被掩埋在历史尘埃中。艺术创作是个人的，唯有
个人才能独特，具有个性化观念的作品才会独秀于林，而被艺术史保存
下来。

8. 灵感无时不有，无所不在，但只有艺术家的「妙手」，才能把握机会捕
捉住这突如其来的「暴发性原创」。艺术家正如音乐家或诗人，必先具
有丰富的感情与深厚的学养，才能在孕育出灵感时，以纯熟的技巧来捕
捉住灵感，并借着绘画元素将其表现出来，创造出令人神往的杰作。

9. 创意作品是永远不死的；没有创意，作品未生即死。

10. 不走别人走过的路或跟着前人的脚步走，不唱与别人一样的调。当看到
到处都是「似曾相识，千佛一面」时，即使已被主流舆论奉为金科玉

律，也千万不要再跟着玩下去。跟着前人的脚步或走别人走过的路，你将永远落后一步，永远扼杀自己的风格。新路是故意的落荒者走出来的，前面没有路就自己开路。

11. 艺术的创造虽是自我的表现，但也可表达民族或全人类的情感。创造不必局限于情感，要像淘金者一样，千万次冲刷出深刻而微妙的新观念来，这才能使得自我放大成人类。

12. 艺术的创作颇像生物科技的基因工程。生物要产生新的品种，必须引入新的基因组接出新的基因链。创作也一样，希望有新的风格、新的形式、新的内容出现，就必须要有新的艺术基因来组接。颠覆与重建，可说是现代艺术的基因工程。我个人就是用所谓「现代绘画基因工程」的观念来重建与突破的。对我而言，每次的突破、颠覆意味着更多、更大的挑战与冒险；而不突破、不颠覆则是更大的不安与痛苦。

13. 艺术家需要建构自己的艺术基因库，懂得从异质文化的艺术宝库中寻找新颖的艺术基因，加以萃取后，以创造新物种的方法，创作出无疆界的艺术作品来，这才是上上策。我从台湾原住民艺术中萃取了两种「基因」：强烈的色彩和鲜活的生命力，也从唐朝的狂草里，萃取丰富的图像及其音乐性，它给我的绘画引进了新的创造基因链，产生新种的艺术产品，所以我的绘画创作其实是一种绘画的基因工程。

14. 文化的创造活力一如生物的基因重组，多元的文化基因，自能产生泉源活水般的创作生机和成果。因此对不同文化要多学习、多认识、多交流，并加以认同。「去文化」则是对创造力的杀戮。

《數位空間系列》（雙聯畫），1999，複合媒材、畫布，130×192公分
DIGITAL SPACE Series diptych, 1999, mixed media on canvas, 130×192cm

15. 创造是将已有的各种元素加以新的组合，它不是无中生有，而是原有的各种元素因重新组合，而衍变出不同的成果。在自然科学领域中，创造意味着进步与提升，但在艺术的范畴里，并没有所谓进步。与其说创造是进步的，不如说是人类固有的「视觉形式」之新发现。事实上，整个美术史就是一部「视觉形式」发现的历史，所以艺术上没有什么进步、不进步的说法。

16. 画之三不主义：（一）不仿古人：画画不可照抄古人，不走古人走过的路，要从古画中走出来。（二）不仿今人：仿今人与仿古人是一样的。（三）不仿自己：不要抄袭自己、重复自己，要勇于挑战自己的过去，再创造新的内涵及面貌，才能提升艺术价值。

17. 艺术的本质是创新，要创新一定有很大的压力，有压力才能突破。这压力不是来自外部，而是自己。一个艺术家若轻轻松松作画，没有压力，绝不可能突破，更谈不上创新。创新的机理是自我颠覆，这等同于自残。无论是自我压迫，还是自残，都是自找的苦。因此德国大诗人歌德才会说，艺术的根是苦的，因此其果实才会是甜的。

18. 一个人如果兴趣跟事业相配合，那是最好、最幸福的。但喜爱艺术创作，可能会经济拮据潦倒落魄，要有心理准备才好。要做自己喜欢的事，就要勇于面对一切困难。遇到挫折不可轻言放弃，要执着、不妥协、不变节，最后才能看到成果。艺术创造的历程艰难崎岖，没有什么快捷方式可一蹴而得。

19. 艺术不是短程冲刺，它是跑一辈子的马拉松竞赛。一个艺术家必须能在长期艰苦、孤单的环境中，展现出「路遥知马力」的「执着」与「专业

精神」。

20. 「人生短而艺术长」，艺术是一种短暂与永恒的生命觉悟，创作更是一条孤单、艰苦的漫漫长路。真正的艺术家，宿命地要一辈子无怨无悔地坚持。

21. 我个人不认为艺术创作必须与人生经历的痛苦、不幸……等画上等号。艺术史上有名的艺术大师，并非人人都活在愁苦中。鲁本斯是个乐天派，哥雅很懂得自娱，梵谷也很满意自己的绘画工作。我觉得世上没有比画画更有趣的事。我认为艺术家的生活，就像是一场令人心醉神迷的梦，只要一天不画画或冥思，心里就会觉得缺了什么似的。艺术是我的信仰，我的一切。

22. 与艺术大师或大思想家直接会晤、交谈、思辩，可以高效率地阅读他们的大脑，聆听大师的智慧，从他们那里汲取各自独特的思维模式、生活风范、艺术观念、技巧和经验，引进自己的艺术基因库，寻求组接出自己的艺术风格的新「物种」。

23. 突破过去传统的思考、技法和诉求，才有可能在创作上有所进展，这几近是公理。然而这种突破，应该是沿着艺术史轴线的「加法」，即要加进「更新颖而精致的形而下表达」、「更精深而契合潮流的形而上意义」，或者是「对世界崭新的感知方式」等等。

24. 艺术家对传统不只是要接受，还要能提升。对传统了解得越深厚，提升就越容易。

25. 艺术是一种视觉语言，系由纯粹的造形元素——色、形、空间、线及点等所组合及构成。因此，仅靠文字，实在不足以传达其内涵。

26. 法国名作家、诺贝尔文学奖得主卡缪曾经说过，艺术家是为美与痛苦而工作；我则为美与快乐而工作。现代人压力大、生活紧张、焦急烦乱与心情浮动不安，痛苦很多，那不是我想要表现的。人们已经够苦闷了，我不想让赏画者再感受抑郁与烦闷。我要画出人生的愉快、喜悦、热情、光明、自由与美丽的一面，并让人们的视觉重获舒畅与自由，就像贝多芬的《快乐颂》。我要在画布上画出我的《快乐颂》。

【贰】艺术家

27. 艺术家有三种类型：（一）一种就像影歌星，很会作秀，喜欢炒作新闻，善于宣传，是商业型、明星型艺术家。（二）另一种艺术家的作品一流，具原创性，但不愿作秀，不善于宣传，名气没有那么大，是专业型艺术家。（三）最后一种是一流艺术家，优游于商业与艺术之间而收放自如，是兼顾艺术与商业的艺术家。

28. 艺术史所肯定的是持续长期创作所累积的艺术成就。然而，长江后浪推前浪，前辈艺术家如不能「与时俱进」，不断创新，就会像时装或电子产品那般，被逼出舞台。倘若这样，「累积」就会被阻断，功亏一篑。

29. 在信息发达的E时代，现代艺术家不但背负着承继本土传统的使命，也肩负着国际艺术新潮创作的责任。因为，现代艺术是无疆界的。

30. 现代的艺术家较易被外在表面的商业包装、掌声……等所蒙蔽，忽略艺术内在蕴含的动人力量，十分可惜。真正能「感动艺术史」的，唯有内

在蕴含的艺术感情力量。

31. 成名是一件好事，但成名后不可原地踏步，应更加努力突破，这样才能不断爆出火光，才有更大的成就与声名。艺术家无不感叹「成名容易保名难」。

32. 绘画艺术在为人类大众开拓新的视觉空间。然而，真正的创新又是曲高和寡，疏离人群。一个要合群，一个是不得不离群，艺术家就在这悖论中受罪。苦啊！这是艺术家的原罪！宿命的原罪！

33. 「作秀」是对专业的「亵渎」。有些画家喜欢作秀，那些动作只会干扰创作，对艺术创作毫无助益。

34. 学画，并非人人可以成为画家。在人类历史中，从事艺术创作的人多如银河繁星，而能在美术史留下名字的，却只有寥寥无几。这说明了一件事：艺术家是从事多彩多姿的高风险事业，是一种永远没有退休的行业。对于学画的人，我要奉劝他们，学画是为了接触美的事物，丰富自己的生活，成为专业画家并非目的。我由衷地期待他们在快乐的学习过程中，能够培养出对「艺术之美」的欣赏能力与像「艺术品」那样美的人格品味。

35. 艺术是一项永无止境的工作。我从十七岁开始学画以来，一甲子的岁月，一直都在「上学」，不断攻读「新学位」，没有毕业可言。

36. 如果把艺术创作的层次比喻成金字塔的话，大致上可概分为三个层次。金字塔的顶端是极其少数，能跨时代建立起新艺术价值观者，包括各主

义画派的拓荒者与先驱者，如毕加索、马谛斯、康定斯基、杜象……等人，他们像科学上的牛顿、爱因斯坦，不但建立了新的艺术价值观，开创艺术新视野，且其艺术观深深影响了以后的艺术发展，居功厥伟。第二个层次为已建立了自己风格的艺术家，他们能建立自己独特的艺术语言与面貌，已属不易，可算是相当成功的艺术家。如果他们能不断地突破既有之风格，并不断地以新面貌展现自己新的艺术内涵，则将更难能可贵了。底层则为绝大多数未能建立自我风格的一般画家。

37. 真正艺术家的创作并不在乎观者能否了解或欣赏。若画家为了迎合世俗，画一些迎合绘画市场导向的画作，虽然能卖画，解决画家生活的问题，但那只是出卖技巧而已。如此只会抹杀其艺术价值和前途。所以，艺术家要淡薄名利，视富贵如浮云，才能创作好的作品。真正有成就的艺术家都是专职创作的专业画家，他们均以创作为职业，并引以为荣。

38. 参加画展是走向职业画家的方式之一，但参展不代表全部。而得首奖的人未来的发展也不一定比无名次的人好，因为它只是个艺术生涯的开始或者连开始都没有。只有谦虚、努力、自信、热情、坚韧，我相信是成为一位成功画家的必备条件。

39. 快速成功对不少人来说已习以为常，这在许多行业可以行得通，尤其是高科技产业，但对建立独特风格的艺术家而言就不是这么一回事。真正的艺术创造过程都是艰难漫长的，没有什么快捷方式可一跃而达顶峰，故艺术不能急。成功之路必需花漫长的时间，苦心孤诣去经营。然而时代节奏的改变，使得许多从事现代艺术的人用艺术的「麦当劳快餐」加激素灌食，希冀快餐速长。

40. 艺术家不同于运动员或歌星，经由五年十载的短期努力和训练便可成就。在艺术创作这块土地上，需要艺术家投注生命和热情全力及长期耕耘，方可发芽抽枝，开花结果。

41. 作为一个画家，最重要的特质，第一要执着，坚守他的艺术立场，执着于他的创作理念，不变节、不妥协，始终如一。第二必须有专业的精神，忠于艺术、忠于自己，不要心有旁骛、偏离正轨。不能「冬天卖热，夏天卖冷」地去迎合绘画市场的口味。具备执着与专业精神，无怨无悔，才能成为一个真正的画家！

42. 画家必须寻找自己的绘画语汇，而不是一味地跟随在美、法等国大师的后面卖力模仿，拾人牙慧。因为即使你模仿得再好，充其量也只是别人的影子，永远不会有自己的「品牌」。品牌的建立非一蹴可几，必须投注生命，长期耕耘。

43. 只有平凡的画家与作家才会循规蹈矩地使用别人的绘画语言和文字。真正的艺术家必然深刻了解「青出于蓝而胜于蓝」的道理，绝不会满足于「等于蓝」的境界。

44. 「风格」是表达画家个人特性和思想的一种方式，是画家的标志，它能使作品带有明显的个人色彩。一个艺术家建立自己绘画的风格，也就是有了自己的绘画语言，有了自己独特的面貌。从这个角度来看，一位优秀的画家同时也将是一位绘画语言艺术家。

45. 建立自己的风格难，突破或颠覆已建立的风格更难。艺术家最艰难的工作在于如何不断地超越自己，寻求突破、颠覆，并不断地以新面貌展现

自己的艺术内涵。一个艺术家的创作风格停止变化，不能突破，就意味着艺术生命的死亡。

46. 伟大的艺术家须走在时代之前十年、五十年或更远。

47. 艺术的先驱者和叛逆者永远不畏挑战。他不但要超越别人，更须超越自己。即使超越了所有的人，也不该自满而怠惰下来。当然，最难的超越，正是已经成功的自己。

48. 伟大的艺术家，一如科学家牛顿、爱因斯坦，探险家马可波罗、哥伦布等，有一种勇往直前的无畏精神、一种憨劲傻气，深入艺术领域的「万径人踪灭」之地进行探险。

49. 凡是在艺术上有一种新的思想或流派出现的时候，必定会受到一些保守人士的抨击或谩骂。如果没有坚强的信心与意志，那是会被击倒的。从事前卫艺术创作是一条孤单而艰苦的漫漫长路！

50. 共产主义国家都由政府来照顾艺术家，因过度保护艺术家，像把鹦鹉放在鸟笼中养起来，以致艺术家生活过得太安逸优渥，结果是创作的活力与灵性被销蚀，而无法如庄子的鲲鹏扶摇九万里、浪击三千里了。

51. 画家可兼理论家，如康定斯基，但不可画家兼艺评家—不可球员兼裁判。但有些人集画家与艺评家大权于一身，权力魔杖使他不再是画家，也不是艺评家，角色混淆而沦为艺术掮客。

52. 廿世纪的两位艺术大师毕加索与马谛斯，他们各自建立了新的艺术价值观，影响整个廿世纪艺术之发展。他们一生创作的绘画作品，主题与风格多元，变化多端，十分丰富，每个时期都有不同的内容与风格。尤为可贵的是，他们作品中所传达的自由感，正是现代艺术家乃至现代人的维他命。

53. 美术家阅读美术书籍，不只要「看画」，也要灵悟其「内文」，以领略其创作的思想观念与创作背景，这样才能加深对作品的认识与感受。

54. 国际当代艺术双年展就像个大市场，有好的货品（有创意的作品）才能获得青睐，没有好的作品，就没有人问津。这个「国际市场」永远有学不完的东西。不仅如此，画家若能受邀参与国际大展，跟来自其它不同国家地域的画家竞争，产生新的「激活因子」，来日必有连自己都觉得惊异的神来之笔。

【叁】艺术作品

55. 艺术品是空间最好的美容圣品，而墙壁是为艺术品服务的。若在冰冷的墙壁上挂一幅好画，顷刻间便能使蓬荜生辉，生气盎然，像上帝创造亚当那样，手指一点，就有了生命的精、气、神。

56. 买画是对专业画家最大的鼓励，也是对「造美产业」最实质的赞助，它是支持专业画家不断工作的工具。创作者有了各方的鼓励，才能持续专心致力于创作。

57. 富豪们经常一掷万金，购买名家的名画，其中有一部份人的确是基于艺术兴趣与品味。但也有不少人常常是为了投资生财、免税节税、附庸风雅或博得慈善美名，尽管原因不一而足，无非希望能为铜臭的外表喷上一点艺术香水，亦即把「铜臭味」变成「铜香味」。尽管如此，社会上的艺术风气和水准会随着蓬勃提升起来，这也就是著名的经济学家亚当·史密斯所说的「看不见的手」。

58. 过去华人富豪的慈善捐赠受传统文化和宗教影响，除了对宗教做功德为来生求福报外，通常是一毛不拔的。这二十年来，好不容易有企业家感到有一种回馈社会的义务，拿出一些钱，设立文化艺术基金会，帮助艺术文化工作的推动。对华人来说，这是很了不起的文明转折点。而意大利十六世纪文艺复兴时期的梅西迪家族、美国的洛克菲勒以及保罗盖帝等扶植艺术的楷模，他们早就懂得这样做了。我们的富豪比梅西迪家族晚了500年。

59. 主宰作品的好坏，不在「漂亮」，而是「创意」和「内涵」。

60. 艺术终归是艺术，真正好的艺术作品终会有扬眉吐气的一天。那些原创性不足、品质低劣、只靠炒作或地域性情感因素哄抬的作品，只能风光一时，无法维持长久。任何人为因素都是一时的，只会昙花一现，经不起时间的考验。

61. 一幅好的艺术作品，必须成为观赏者所呼吸的清新空气，这样的作品才有生命可言。

62. 画「大画」不易，作「小画」亦难。画「大画」不是像照片般放大扩张，它必须有足以支撑大画面的架构及内容，需有深厚的技法基础以及艺术修养，才能画出气势磅礴、如交响乐般令人震撼的巨幅大作。画大画切忌犯「大而不当」，而「大」未必等于「好」。波洛克的巨幅抽象画，正因为有了上述的前提，才有撼动观者的美感力量。小画则是在方寸之地铺设锦绣大世界。精美的小画，若看起来仍有「大画」的感觉和气势，才算得上是好画。克利的小画就是这样，尺幅之内却蕴藏着天文数字的丰富性，非常耐看。

【肆】我说我画

63. 我的作品一幅幅都用色彩表现出生命在大自然中的跃动和欢愉。

64. 我的每幅画都是在不断冥想的过程中随机完成的。米开朗基罗对着大石头冥想，待看到石头中的激动，他才开始动刀。我在动笔前，像日本茶道那样静静坐在画布前，凝视着空白的画布，冥想出意境，再由意境构想出造形和色彩。这时嘴里念念有词说：「啊！我要这样画！」立即动笔，急切地把那藏匿的内在经验投射到画布上。所以我在空白画布前冥想的时间，有时会超过实际作画的时间。

65. 我认为中国的文字是世界上最美的文字，尤其是狂草，本身有流动性、韵律感、节奏感，于是我用它来作为绘画的基本元素。

66. 中国的文字本身具有音乐性，而且文字与文字之间也有音乐性，尤其是唐朝的狂草更具音乐性，它可成为艺术创作的新元素。

67. 色彩和线条在我的绘画中一直扮演着重要的角色。我不单把二者从描述的功能中完全解放出来，发挥其固有功能，使其回复到最纯粹、最简单的绘画形式；并将它的单纯化和纯粹化推向顶峰。这样作品才会如同音乐一般的纯粹，具有很高的精神性。

68. 绘画是色彩的游戏，也是心灵的游戏。

69. 我一直认为色彩本身就能产生形象与主题，而空间也可借着色彩来建立。所以，色彩在我的作品中的确担当很重要的角色。我也一直努力把色彩的纯粹化、单纯化推向顶峰。

70. 我从本质艺术（essential art），即从色彩、造型出发，让色彩成为观者与画家间视觉与精神的桥梁，让观者能跨越门坎，进入那五彩缤纷、灿烂夺目的世界，并把绘画提升到精神层面。康定斯基说过，抽象画就是色彩与形象的一种安排与组合，所以如果能够从本质艺术出发的话，那么色彩与形象可以发挥得更生动、更完美。

71. 我画画从来不打草稿，一向采取「自然生育」的方式。我直接把颜料泼洒在画布上，把内在生命与情感直接诉诸作画行动，就像女人的「自然生育」一样，不是「剖腹生产」。如此，画家内在的生命与情感才不会被减弱或歪曲，而产生了不自然的「人工生育」。我认为，若透过草图小心翼翼地作画，难免会减弱内在的生命力。

72. 我是基于对大自然深切的体验和冥想来创作的。自然中那恢宏的大气、光辉绚烂的色彩，给了我无穷的天启与灵感。

73. 我始终忠实于自我的内在世界，坚持抽象艺术的表现形式，因为它是最纯粹的绘画表现形式，所以我绝不会妥协或变节。

74. 我创作得之于苦心「创作」的少，而出于深刻「思考」的多。

75. 我使用油彩、压克力彩或复合媒材作画，都无法像画水彩或水墨般，当天快速完成。为了突破与创新，几乎每一幅画画完后我都会将其留在原处，每天以不同的角度反复审视。所以每一幅画都需要修改多次，不断思考、斟酌、推敲，往往要数月甚或半年才可完成。画画真是「慢工出细活」啊！

【伍】抽象画

76. 写实画就如谱上唱词的歌，美则美矣，然意境有限，双重限制了创作者和接受者的想象力。抽象画则若无词的乐曲，乃是一首色彩交响乐，涵盖着无限丰富的生命。意境犹如不断膨胀着的宇宙，无论创作者和接受者，都可驾驭着想象乘风而去，它是「视觉的音乐」。

77. 抽象绘画旨在唤醒埋藏在生命最深邃处的美或情感。

78. 抽象艺术之创作，只有出于内在感情的强烈需要，才会真诚动人。这内在需要又与现实生活中的体验密不可分。

79. 人生是不自由的，但是抽象艺术能给心灵以「接受美学」上的审美自由，能给人一种天马行空的境界。

80. 我始终不渝地忠实于自我的内在世界，终生不懈地坚持抽象艺术的表现形式，因为它是最纯粹的绘画表现形式。我将与她「在天愿作比翼鸟，在地愿为连理枝」。

81. 诗是无形的抽象画，而抽象画是无声的诗、空间的诗。

82. 提升欣赏抽象画能力的良方，是营造学习欣赏抽象画的生活环境。在家中或办公室里挂上几幅优质的抽象画，和它们生活在一起、工作在一起，营造耳濡目染的审美氛围。易言之，就是要浸淫在抽象画的环境里，这将有助于提升美感品味与对现代艺术的逻辑思考力。从熟悉中体会抽象画的内涵，不失为了解和欣赏抽象画的良方。这就如同在家里经常听古典音乐一般，能培养对音乐美感的感受力。

83. 抽象画不是能不能欣赏的问题，而是在于自己肯不肯突破陈旧的观念，多花时间，多下功夫去学习和研究，并以真诚的态度去接近它。

84. 上个世纪末开始，人类进入数字时代。这以「0」与「1」两个最简单数字元素所建构的虚空间，改变了整个人类的生活方式。人们通过因特网来到一个信息浩渺的无垠空间，我强烈地想要以绘画来表现这个触摸不到的神奇空间。我想这抽象的三度空间，唯有以表达内在经验为诉求的抽象绘画，才能灵动变现。

85. 抽象画的定义和精神一直被一些人误读、误解并误导，以致在海峡两岸有所谓「抽象山水」一词。既然前面冠以「抽象」，其形象必然是「无法辨认」、「无可名状」的，怎么还会清清楚楚辨认出「山水」呢？这显然是不合逻辑的。在海峡两岸，因为对抽象理论的不求甚解，「抽象绘画」一词经常被曲解和滥用。

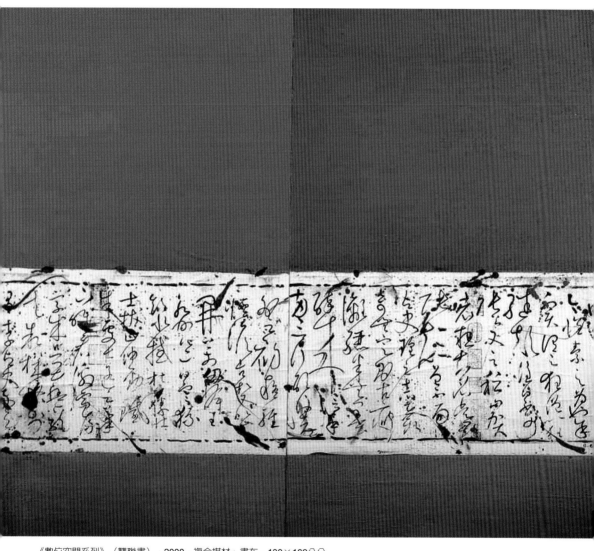

《數位空間系列》（雙聯畫），2000，複合媒材、畫布，130×162公分
DIGTAL SPACE SERIES diptych, 2000, mixed media on canvas, 130×162cm

86. 有人认为「抽象画」的观念与精神中国古已有之，甚至还说在中国美术史上绵延了三千年之久。事实上，中国美术在古老的「中庸」和「中和」的哲学精神指引下，从来就没有真正臻于纯粹或完全抽象的境界，总是在「具象」与「抽象」之间游移徘徊。我们从唐朝水墨画家张彦远的「夫画最忌形貌采章」，以及北宋苏东坡的「绘画以形似，见与儿童邻」等的绘画思想，即可看出当时水墨画家停滞（或游走）于「具象」与「抽象」之间。

87. 廿世纪初诞生的抽象画，其观念和精神内涵，与中国史前时期的彩陶和三千年前的商周铜器上的抽象「纹样」截然不同。盖中国史前时期的彩陶和商周时期的铜器图案纹饰虽然都是抽象形式的纹样，但这些纹样均属「装饰艺术」的范畴，而非「造形艺术」的范畴，这是二者本质上与功能上的最大不同。盖装饰艺术的创作基本上是重「实用」和「装饰」功能，且都无落款；而廿世纪诞生的抽象画是由绘画基本元素、形、色、线、空间等所构成和组合，它讲究视觉元素间的复杂组合关系，其创作源于艺术家「内在需要」，并传达其内在经验的真相及探索内在世界的奥秘。因此，二者不可混淆。

88. 色彩是朝向抽象发展的一个重要课题。要往抽象的大道迈进，只有两条路可以走。一是从色彩出发，一是从形象出发。康定斯基、德劳奈、库普卡是从色彩出发抵达抽象艺术新天地的；而蒙德里安、马勒维奇等则是从形象之路登上了抽象艺术群山的又一峰。

89. 回顾台湾抽象绘画创作的世纪跑道上，有半路换跑道的、有落荒当逃兵的，大有人在。我想，或许是因创作艰辛，而又曲高和寡、知音难觅，最终因画作得不到收藏家之青睐而难以维生吧！

《福爾摩沙頌》（三聯畫），2006，複合媒材、畫布，130×192公分
ODE TO FORMOSA triptych, 2006, mixed media on canvas, 130×192cm

90. 我把推展抽象艺术当成一种美的信仰的传播！因此，我以传教士般的热忱在海峡两岸传播抽象艺术，以抽象艺术的传道者为己任，努力让自己成为「美的推手」。

【陆】中西艺术

91. 国画与西画，其媒材、工具、美学意趣都不同，科学哲学指出，不同规范不可比优劣。因此，二者万不可楚河汉界，相互藐视，应该相互吸收其长处，将中西画的特色加以融合。控制论鼻祖维纳说，两个不同学科的交接部往往是一门新学科的产床；那么，国画与西画的交融，也可期待一种新艺术的诞生。

92. 中国首次大量吸收异质文化（alien culture，即外来文化）是南北朝时代。那时东北有契丹，南有印度，西有吐谷浑、波斯甚至罗马帝国。因此，中国艺术不断演变，累积到大唐而绚烂释放。

93. 现代艺术已推翻优美的古典标准，故中国艺术家面对整个世界艺术潮流，要以开阔的胸襟去吸取异质文化的精华与养分，并与本国文化融合。这样，才能创造一种更宽阔、更深远、颇具异趣的作品，这本是「有容乃大」的中国文化之特性。作为一个现代艺术家，光从前人的艺术作品中汲取一些技巧与经验是不够的，除此之外，还需汲取异质文化。所谓异质文化即完全不同的外来文化，对于西方画家来说，外来文化包括中国书法、日本浮世绘画、东方木刻版画、禅画、台湾原住民艺术、非洲及大洋洲之木雕艺术、心智残障者及儿童的绘画…等，艺术家由此获取开创新流派的灵感与启示。例如毕加索从非洲黑人原始雕刻获取灵感，而在造形上产生重大的突破。梵谷则从日本浮世绘画获取启示，他的色彩变得更为明朗，并发展出书法的线条。而抽象大师哈同、

苏拉奇以及克来恩等人均从东，书法中获得灵感与启示，产生富有韵律与节奏感的书法抽象风格。

94. 对艺术创作的长期投入与专注，对民族传统艺术的深刻了解，并从中吸收养分，以宽大的胸怀汲取异质文化的精华，融会贯通，将有助于自我风格的建立。

95. 有人说：「现代人创作的绘画，就是现代画。」这种说法就好像「中国人画的画，就是中国画」一样不合逻辑。因为有些现代人的创作观念还停留在十八、十九世纪，有些中国人画的画，像西方人画的画。我国现代艺术至今尚未走出模仿西方人的局限，即使是中国人画的，也仅掺入些许东方技法或地域色彩，仍全盘采纳西方艺术的技巧和观念，因此，看起来都「似曾相识燕归来」。

96. 西风可借，但仍需奠定东风的基础，唯有阔大的东风基础才有足够兼容西风的潜能。中国艺术家必须懂得挖掘中国传统文化与艺术的内涵，在「借西风」的过程中将其转化成现代视觉语言，创造出富有东方特色的视觉艺术，这是中国艺术创新和走向世界的一条广阔大道。

97. 结合西方的表现工具和形式，或吸取西方经验才是中国水墨画发展的唯一途径。中国水墨画是中国独特的艺术，它是以笔墨的情趣和意境来展现我国儒家、道家以及佛教的思想。但自宋元以来，即以师承和临摹为风尚，往往拘泥于中国传统水墨的技法。今天大部分的中国绘画之所以如此贫血，会走进死巷，是大部分画家闭关自守，因循守旧，而不敢放胆创新，痼疾是缺乏多方面的文化营养。其解决之道，可与西方的技法合璧，跳脱摹拟，走向创新。

98. 对于一个中国的现代艺术家来说，在创作素材和技巧上，可以不完全属于中国，但在精神上却是必须回归于自己的传统。因为传统是一项丰富的资产，一个艺术家绝不能忘却本身的传统，不过也不能以只做地域性艺术家为满足，应以发展成一个国际性艺术家为职志。

99. 东方人要成为国际艺术家，应该把东方人传统的美以及文化中对美的意识完全表现出来，才能找到真正的自我。若找不到自己的归属和定位，国外艺术家也不会认同我们。因此，我一生都在努力寻找「东方与西方的交融－meeting」。

100. 现代艺术家应该有「立足本土，放眼国际」的眼光和胸襟，不要只满足于目前在国内的成就，应该走出去，与国际艺术界交流，相互砌磋观摩。画家像球队一样，需要经常参加国际性大展，与其它国家的艺术家比较，才知自己的实力；否则，如井底蛙，不知天高地厚。问题是参加国际展谈何容易，通常须经过国际评审团或策展人之邀请，才能获邀参展。

101. 廿一世纪是东西方艺术文化融合的大时代。未来的世界艺术中，中国艺术将是很重要的一部分，国际艺坛将看好华人艺术家未来的表现。华人艺术家只有抱持「有容乃大」的中国文化特性，对东西方文化深入研究及了解，才能把二者融合起来，创作出现代的中国艺术。这样，一定会对世界艺术文化的发展有所贡献，而为全人类所肯定，此一理想也是我对自己未来的期许。

【柒】艺术教育

102. 要成为一个艺术家，不是只依托学校教育。毕业后必须建立自己的艺术观，努力走自己的路。老师只是艺术教育者、一位引路人或启蒙者而已，不是万能艺术家，美术教育不是培养现在最流行的美术。如果学生只学了老师这一道菜，五年、十年之后，他们就不知所措。譬如说吧，目前装置艺术风行全台，美术馆也经常举办，但装置艺术在美国早已开始式微了，那学校还要不要再教装置艺术呢？所以，学校里的课程要有现代规画。不是教会学生某种新流派，而是让学生受到现代艺术观念、技法与原创意识的训练；换句话说，不是给学生一只鸟，而是给一把能打鸟的枪，这就是教师与做一个艺术家的不同之处。

103. 美术院校的学生，每人画出的东西都差不多，缺乏个性。而老师的主要工作不是纠正学生的技巧，而是应该透过讨论，帮助学生寻找自己的绘画语言。

104. 艺术家一定要能独立思考，有能力建构自己的思想，但我们的美术教育太过保守与严苛，无法给学生足够的空间让学生成长发挥，所以我们的美术教育有时会成为阻碍。

105. 在学校课堂里学习的知识与技法，不论教材与教法，仍显得保守，缺少启发性和创造性，依样画葫芦，很多已经过时，甚至是错误的。长期以来，教授美术的课程已经僵化，因此，须要更新教学课程，这样可缩小教学大纲与最新艺术发展之间的差距。至于社会美术教育方面反倒是比较成功的，尽管其规模是零散的，声音也不大，但影响力却是深远的。

106. 一般老师所教的都是那个时代的想法和技法，等到学生学会时已嫌老旧落伍了。因此，学生们应该超越老师，做和老师不一样的事。

The Sayings of
Chen Cheng-Hsiung on Art

Preface

Words of Wisdom
——The Artistic Thinking
and Originality of Chen Cheng-Hsiung

Chen Cheng-Hsiung (a.k.a Robert Chen) (1935-) is a singular character in post-war Taiwanese art. Without the benefits of professional training, Chen has emerged as a preeminent painter for his thorough understanding of abstractionism and prolific creative accomplishments. As early as 1991, Chen joined the *Salon de Mai* in Paris as one of only three invited Chinese painters, including Zao Wou-ki (1921-2013) and Chu Teh-Chun (1920-). Greater achievements came in 1999 and 2001, when Chen twice won the *Florence Biennale*'s highest honor—the prestigious *Lorenzo il Magnifico Career Achievement in the Arts Award*. For over a decade, Chen has been a missionary of abstract ideologies and works, speaking by invitation from China's major artistic academies, including the Beijing Tsinghua University, China Central Academy of Fine Arts, Renmin University of China, China Academy of Art, Hangchow, Sichuan Fine Arts Institute, Sichuan University, Sichuan Normal University, Chengdu College of Fine Arts, Luxun Academy

of Fine Arts, Nanjing Arts Institute, Fudan University, East China Normal University, Shanghai University, Shanghai Normal University, Shanghai Institute of Design, Donghua University, and Liaoning Normal University. He was also an advisory committee member of Shanghai Art Museum and planner of the Shanghai' Biennial in 1994. In short, Chen's activities in recent years had made him a major leader of abstract art theory in the Chinese-speaking world.

As a first-year student at Taipei Jianguo High School, Chen studied with famous masters Li Shih-Chiao and Chin Jun-tso, gleaming their artistic knowledge and perspectives. Most of Chen's academic accomplishments, however, are derived from relentless self-study. While at university, Chen used his strong English and Japanese abilities to study classic writings on abstract art, including Kandinsky's *Concerning the Spiritual in Art*. During the compulsory military service that followed, Chen studied Sir Herbert Read's classic texts: *A Concise History of Modern Painting* and *The Philosophy of Modern Art*. At the beginning of his career it can be said, that Chen not only stood firmly on the shoulders of his modern art forebears, but had taken a leap beyond their understanding of the craft.

The 1960s bore witness to the emergence of modern art in Taiwan, when public understanding of modernism and abstractionism were sketchy and incomplete, being derived from either subjective or second-hand information.

《再生》（雙聯畫），1997，壓克力彩、畫布，89.5×259公分
REBORN diptych, 1997, acrylic on canvas, 89.5×259cm

Using the knowledge he garnered from studying seminal works, Chen penned the article "On Abstract Art" in the pro-democracy publication *Wen Hsing Magazine* (Issue No. 92) in 1965. The essay delved deeply into abstractionism from both the historical and theoretical perspectives, and provided a thorough academic interpretation of, and introduction to abstract art. In it, he wrote:

> *"Before we can understand abstract art, we must first understand this: rather than say that the nature of abstract art is "evocative" rather than "descriptive". Like music, it's meant to stimulate inner feelings without story-telling, it is intended as an intense expression of the artist's inner experience (feelings, emotions, moods.), it is a "visual metaphor"—not a "visual narrative".*

> *To understand abstract art, one needs to grasp the basic concept that artistic works are tools for stimulating inner experience. In psychology, this concept derives from common association and empathy. 'Common association' is the process by which the relationship between natural phenomena & objects, colors, forms, and lines create a unique feeling and concept. For example, red represents heat and excitement, yellow— the sun and happiness, blue and black—calm and melancholy; biological forms represents life while geometric shapes reflect the logical construct; the horizon signifies peace, as diagonals do action, and right angles do stability.*

'Empathy' is the ability of human imagination to connect intimately with foreign organisms or objects. In art, it is the manifestation of Van Gough's passion, Renoir's joyous aestheticism, Matisse's elegant contours, Mondrian and Brancusi's exacting natures, and Rothko's serenity through color.

Pieces thick with artistic elements and common associations seem miraculously to convey unusually rich emotions, though not all artists can fully utilize their abilities to intentionally arrange the complex relationship needed to convey a unique mood or feeling. The process is often unconscious, even subliminal. Most contemporary artists feel they need only to convey their inner emotions and never intend to record their visual impressions. The great artist is extra-sensitive to certain kind of experiences, and is able to synthesize and express his inner experience in his art with great intensity. For example, where most people saw the French countryside, Cézanne saw a logical organization and unity in nature, Renoir's joyous aestheticism, and Van Gough its struggles and wild fanaticisms. Each individual artist's unique character and strength of inner experience will imbue his works with true meaning."

In 1964, Chen's work *Lemons* won third place for oil painting at the Annual Taiwan Art Exhibition. This win launched his long professional career,

which has since made him one of the few successful painters in post-war era Taiwan. Today, Chen maintains his passion for the written word as a tool in the promotion and guidance of abstractionism's development. A prolific writer since 1964, his most representative works include: "The Popularity of Op Art in Europe and America" (May 2, 1965, *Credit News*), "International Art Trend of Post-World War II" (June 3, 1967, *Central Daily News*), "On Abstract Art" (July 24, 1967, *Taiwan Shin Sheng Daily News*), "What is Abstract Art" (July 1968, *Young Lion Monthly*), and for the popular *Oriental Magazine* in 1968—"Lyric and Geometric Abstraction" (No. 1, Vol. 9), "Precursors of Abstract Art——Cubism and Futurism" (No. 2, Vol. 6), and "On the New York School" (No. 3, Vol. 12). During the 1980s, Chen wrote for the Taipei Fine Arts Museum's *Journal of Modern Art* "The Spirit of 20th Century Abstract Art" (Issue No. 58); for the *Independence Evening Post*, he wrote "Exploring the New Concept of Space" (July 10, 1985). During the late 1990s, in an effort to save the near-bankrupt "Aspects of Contemporary Painters in Paris", Chen penned "Hartung's Lyric Abstraction and Chinese Calligraphy" (April 27, 1997, *Independence Evening Post*). During the following year (1998), as Chen just happened to be in Beijing during the first stop of Chu Teh-Chun's "*Far East Travelling Exhibition*" at the Fine Arts Museum of China, Beijing, he penned the promotional piece "Dawn and Dusk——On Chu Te-chun's Abstract Paintings" (July 23, 1998, *Independence Evening Post*) on his old friend's behalf. He has also published articles in mainland Chinese art journals, including "From Representation to Abstraction" (*Art World*, June 1994) and

《酒的夢鄉系列》，1999，壓克力彩、畫布，105×260公分
THE DREAMLAND OF WINE, 1999, acrylic on canvas, 105×260 cm

"Principles of Abstract Art Appreciation" (*China Art News,* June 10, 2009).

Since the 1970s, Chen's travels have made him a familiar face in the artistic circles of Paris (France), Italy, New York, San Francisco, Hawaii, and Japan, where he befriended many world-famous contemporary artists, including Piere Alechinsky, Olivier Debre, Willem Corneille, Roberto S. Matta, Sam Francis, Karel Appel, Kumi Sugai, and Masuo Ikeda, as well as famous art critics and historians, including Michael Sullivan of Oxford university, America's John T. Spike, France's Jean-Clarence Lambert and Gerard Xurigera, Italy's Pierre Restany, and Japan's Takachiyo Uemura. The long exchange of creative experiences and aesthetic philosophies made lifelong friends of these modern masters. Recorded and refined over many decades, the fruit of these exchanges and Chen's artistic learning, contemplation, and creative journey is now published as the "The Sayings of Chen Cheng-Hsiung on Art"—the first ever book of its kind by a Taiwanese artist. This work is the organized presentation of Chen's artistic theory, as well as a source of guidance and inspiration for students, enthusiasts, and especially fellow and future abstract artists.

The volume is organized by the following seven categories:
1) Artistic Ideals
2) The Artist
3) Artwork

4) My Words, My Paintings

5) Abstract Art

6) Chinese & Western Art

7) Art Education

Each category incorporates 20 to 30 concise and illuminating sayings that run just over 100 words at their most lengthy. For example, Chen pinpoints the essence of art in the opening category, *Artistic Ideals*: "*Art is not the expression of surface experience, but of underlying truth, because this deeper truth is more pure and indicative of human nature,*" directly chastising those sketchers of mundane objects who dare to call themselves painters.

Chen also writes:

> "*It is my aim to explore and communicate the only truth I firmly believe in – the truth of the inner experience (feelings, emotions, moods); and through the basic elements of painting and aesthetic form, to explore the mysteries of the inner world, and transform invisible experience into visible reality.*"

Some assert that there is no absolute definition of art. While this may be true, without the exploration and presentation of inner experiences, art would entail merely the fruitless application of prescribed techniques, which cannot assume as important a role as it has in human civilization. In addition,

while art can encompass diverse perspectives and definitions, the serious artist must formulate them into a workable system that precludes chaos and contradiction.

The Sayings of Chen Cheng-Hsiung on art is the artist's opinions on, and definition of art, also representative of the mainstream thought and definitions of 20th century abstract art. While abstraction is only one of many artistic standards, the revelations and perspectives it pioneered and cultivated rank among major cultural accomplishments of the 20th century. Chen developed his personal artistic philosophy and system on the basis of our shared human civilization, made largely accessible to his audience as a shared human experience. Under *The Artist* category, he states:

> "*Style is the hallmark of a painter, a way for the artist to express his individuality and thought, and imbues his works with a prominent personal flare. By establishing a personal style, the artist is creating his own language of painting and unique appearance. From this perspective, an exceptional painter must also be an exceptional art linguist*";

Furthermore:

> "*Establishing a personal style is difficult, but making a breakthrough or subverting one's existing style is even more challenging. The artist's*

most difficult task is to continually surpass himself, search for new breakthroughs and subversive maneuvers, and present the substance of his art through new faces. When an artist's creative style ceases to evolve, and he no longer has the capacity for breakthrough, it implies the death of his artistic life."

Realizations such as these are indisputable truths for artists both the realistic and abstract styles.

Under *Artwork*, Chen gives "non-creators" the following advice:

"A purchase of paintings offers the greatest encouragement to a professional artist, and the most practical contribution to the beauty-creation industry. It is a tool for encouraging the professional painter to keep working. With encouragement from all directions, the artist can then focus all his energies on creation."

Furthermore:

"Tycoons often pay large sums for paintings by the masters. Among them, a number are in fact art-lovers who recognize the value of true art. But there is also a number who purchase art for the purposes of investment and tax exemption, the veneer of elegance, or building a

philanthropic reputation. No doubt this is done to perfume their exterior and to lend a fragrant aroma to odorous coin. Even so, this "invisible hand," coined by Adam Smith, a noted economist, will stimulate the artistic climate and standards."

To creators, he suggests:

"A large painting can be difficult to work, but a small painting is no easy task either. An image cannot be enlarged like a photograph for a large work, which must have sufficient structure and content to support it. A painter must possess firm technical foundations and artistic mastery to create a majestic and awe-inspiring large work like a symphony. When creating a large work, one must take great care to avoid the impropriety of subject to size, and consider that big is not always better. It is because of the aforementioned virtues that large abstract paintings by Jackson Pollock (1912-1956) possess the power to awe its viewers. In contrast, a small painting is the establishment of a great and splendid universe in a small space. An exquisite small work can only be called great if it can project the same feeling and power as a large work. The small paintings of Paul Klee (1879-1940) inspire just such sentiments—infinite richness on a mere foot of canvas, and worthy of long study."

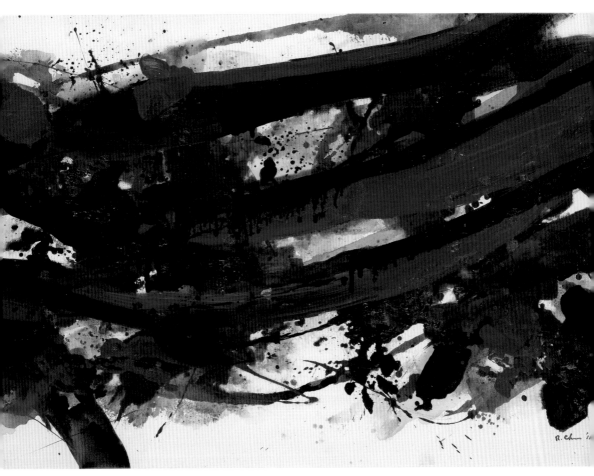

《藝術的高速道》，2011，壓克力彩、畫布，89×130公分
AN ARTISTIC HIGHWAY, 2011, acrylic on canvas, 89×130 cm

The section on *Abstract Art* is a highlight of the book. While many people express difficulty with understanding the Abstract, Chen rectifies the problem by using simple language:

"Realistic painting is like the libretto of a song — it 's beautiful, all right, but the feeling expressed is limited, and, in time, it comes to an end, places a twofold restriction on the imaginations of both its creator and audience, but, abstract painting is like instrumental music, it is a kind of symphony of color; it evokes a life of infinite richness, its scope like the ever-expanding universe in which creator and audience alike can take free reign of their imaginations. It is 'visual music'"

Additionally, while *"there is a lack of freedom in life… abstract art allows the mind the freedom to judge and accept aesthetic beauty, giving the spirit license to soar."* To that end, Chen proposed the following:

"Creating a living environment that is conducive to abstract art appreciation is the best way to enhance it. By placing a few quality pieces in the home or office, so that one can be immersed in such an environment through living and working alongside them, the growth of appreciation will be almost osmotic. Like listening to classical music at home will heighten your sensitivity to musical beauty, the realization

of abstract meanings through experience is a sound strategy for the elevation of one's aesthetic sensibilities and taste."

In response to those who make the dismissive claim that "abstractionism art had already occurred in ancient China," Chen makes the following corrective statement:

"Some believe that the concept and spirit of abstract painting existed in ancient China, even that it has been a part of Chinese art for 3,000 years. In actuality, Chinese art, under the guidance of the ancient 'spirit of moderation' and 'golden mean' philosophies, had never truly ascended to the pure and complete realm of the abstract, but remained mired between representation and abstraction. From the philosophies of Tang Dynasty Chinese ink painter Chang Yen-Yuang, who said: 'In painting one should especially avoid a meticulous completeness in formal appearance and coloring,' and Northern Sung Dynasty's Su Tong-pou, who said: 'Practicing painting in terms of formal likeness, the approach is close to that of a child,' we see that Chinese ink painters at the time were held up (or shifting) between representation and abstraction."

He goes further to explain:

"Born in the early 20th century, the concept and spirituality of abstract art is entirely different from prehistoric Chinese painted pottery and the motifs on 3,000 year-old Shang and Zhou Dynasty bronze implements. The greatest difference between them is that while the motifs on the aforementioned artifacts are abstract, they belong in the category of decorative art, not plastic art. Decorative art is created to be practical and decorative, and are not signed; abstract painting is constructed and arranged using the basic elements of form, color, line, and space, cares particularly for the complicated arrangements and relationships of visual elements, is born of the inner needs of the artist, conveys the truth of the inner experience, and explores the mysteries of the inner world. For these reasons, decorative and abstract art cannot be confused."

Chen is incisive in his comparison of *Chinese and Western Art*:

"Chinese and western paintings do not share similar mediums, tools, or ideas of beauty. And as both science and philosophy declare that cross-category quality comparisons cannot be made, one must not look down on the other, but should draw on each other's strengths, and create a blending of their unique individual characteristics. Norbert Weiner (1894-1964), the originator of control theory, once said that the point at which two separate disciplines intersect is often the bed of a new discipline. If that is so, then we can expect the birth of a new art form

from the meeting of eastern and western art."

Therefore, he proposes:

"Integrating western performance tools and forms, or drawing from western experience, is the only road to advancing Chinese ink painting. Ink painting is a uniquely Chinese art form, manifesting Confucian, Taoist, and Buddhist thought through the appeal and artistic conceptions of brush and ink. However, since the early Song Dynasty period when the shih-cheng (to study under the master(s) of only one particular school) and imitation trends originated, Chinese ink painting techniques have been mostly bogged down by traditional techniques. Because most modern painters remain traditional and guarded against outside influences, so much of present-day Chinese art is anemic and heading towards a dead-end; intimidated by the idea of innovation, their chronic illness results from a lack of broad cultural "nutrition." The way out of this predicament is to innovate through partaking in western techniques and freeing oneself from imitation."

In addition to pure artistic creation, Chen is also a supporter of art education, and has a unique take on its implementation:

"Much of what one learns in the classroom, in terms of text and technique, is considered conservative and uncreative, mere traceries that

are often passé, even wrong. Art education curriculums have been in a state of rigor for quite some time. New courses are required to close the distance between the curriculum and the latest developments in the art world. Art education out in society is more successful, making an impact despite its uncertain scope and scattered distribution."

Therefore, he proposes:

"To become an artist, one cannot rely solely on institutional education, but must establish his own artistic perspective following graduation, and strive to walk his own path. A teacher is only an art educator, a guide or torchbearer, not an omnipotent artist. The purpose of art education is not to nurture contributors to the latest trends. Should the student learn only this from his teacher, they will become inevitably lost five to ten years down the line. For example, Taiwanese museums host frequent exhibitions of installation art, the latest fad in Taiwan, though the art form is already in decline in the U.S. Should schools then teach installation art? From this, we see that the formulation of curriculums must be modernized. The aim is not to teach students the latest trends, but to train them in modern artistic perspectives and techniques, and train within them a consciousness for originality. In other words, instead of giving the student a bird, give him a gun with which to shoot one. That is the difference between being a teacher and an artist."

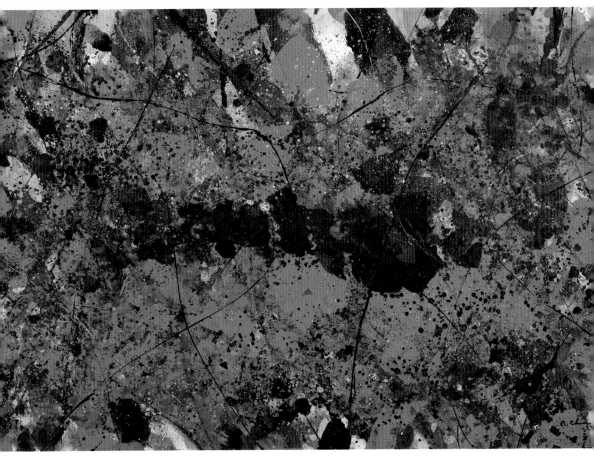

《綠野香頌系列》，1993，壓克力彩、畫布，97×145.5公分
GREEN FRAGRANCE SERIES, 1993, acrylic on canvas, 97×145.5cm

On his own creations, he writes, under *My Words, My Paintings*:

"Through color, each of my works expresses the vivid movement and joy of life in nature."

He goes on to say:

"Each of my paintings is created extemporaneously in a process of constant meditation. Michelangelo (Michelangelo Buonarroti, 1475-1564) put chisel to stone only after meditation revealed the vitality within. Before applying my brush, I sit in silent, chadō-esque (the study of Japanese tea ceremony) contemplation, gazing at the blank canvas before me, contemplating an artistic concept, and from that concept, forms and colors. At the moment when the words 'Ah, this is how I must paint it!' are uttered, I apply my brush and project that inner experience onto canvas with great urgency. The time spent in contemplation sometimes exceeds the actual process of painting."

He explains:

"I never make a sketch when I paint, I always go for a "natural birth". I put paints to canvas directly, investing all my life and emotions into the act of painting—like a woman birthing naturally, not having life

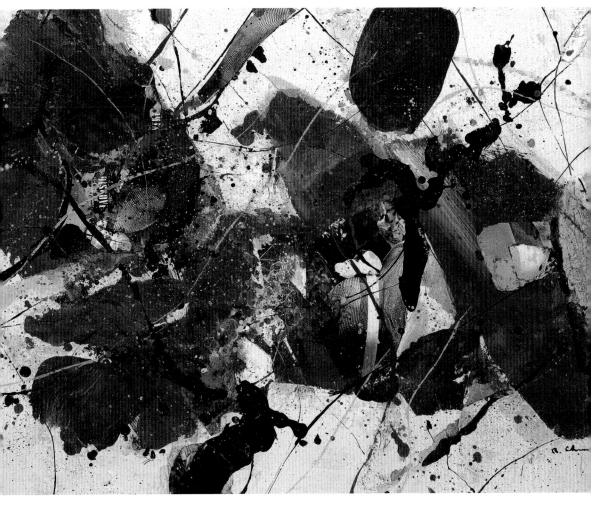

《咖啡之夜》，1990，複合媒材、畫布，80×100公分
COFFEE NIGHT, 1990, mixed media on canvas, 80×100cm

wrenched from her by the edge a knife. In this way, the life and emotions of the artist remain undiminished and untwisted, and his creations do not become unnatural and artificial. It is my belief that working carefully from a sketch would inevitably diminish the life force of the artist."

In conclusion:

"*My ideals stem from essential art, from colors and forms, allowing color to bridge the gap between the visions and spirits of the audience and painter; allowing the audience to step through the entryway into a dazzling world of color, and elevating painting from the realm of the physical to the realm of the spiritual. Kandinsky said that abstract art is the arrangement and combination of colors and forms; therefore, using essential art as the starting point will allow a more lively and well-rounded expression of colors and forms.*"

All in all, these seemingly independent sayings are the components of an artist's complete system of thought derived from long contemplation and practice—it would not be wrong to call them "Chen Cheng-Hsiung's Artistic Perspective" or "Chen Cheng-Hsiung's System of Artistic Thought." Many of the Sayings draw attention to the originality and inspirational nature of modern scientific thought. In *Artistic Ideals*, Chen proposes the following:

"*The creation of art is strikingly similar to genetic engineering. The creation of a new breed must employ new genes to create new genetic chains; it is the same for the artistic creative process. If one wishes to create new styles, forms, and content, one must employ novel combinations of artistic "genetic" material. Subversion and reconstruction is the genetic engineering of modern art. I myself utilize the concept of "genetic engineering of the modern painting" to reconstruct and make breakthroughs. For me, every breakthrough and subversion implies even more and even greater challenges and adventures, when they are no breakthroughs and subversions that are even more unrestful and painful.*"

Furthermore:

"*The artist must establish a personal store of artistic "genes", and know how to seek out and select novel components from the treasury of alien cultures (i.e. cultures foreign to the artist's own). The utmost artistic strategy is the utilization of these materials to create new species of art and works of boundless meaning. I have extracted two such "genes" from Taiwanese aboriginal art: intense, striking colors, and a vibrant life force; I also draw on the imagery and musicality of Kuang Tsao, the most freely cursive style of Chinese Calligraphy. These elements have provided me with new creative genetic chains for new artistic*

creations; my creative process, my painting, is actually a kind of genetic engineering."

Therefore, he believes:

"The creative forces within culture can be likened to genetic recombination in an organism; a diverse cultural genome will naturally lead to a fluid creative-vitality and achievement. It is therefore important to acquaint oneself with, and learn as much as one can of different cultures, to create opportunities for exchange, and to understand and appreciate them. To discount culture is to slaughter creativity."

Here, Chen is both interesting and theoretical.
On *Abstract Art*, he says:

"The human race entered the digital age at the end of the last century, and the virtual space, constructed of the elemental digits '0' and '1,' has completely redefined the way the human race lives. Through the World Wide Web, mankind has entered an infinite space where information is both vast and endless, a fantastical, intangible space that I so vehemently wish to manifest through painting. I believe that this abstract third dimension can only be effectively displayed through abstract painting, whose only pursuit is the expression of inner experience."

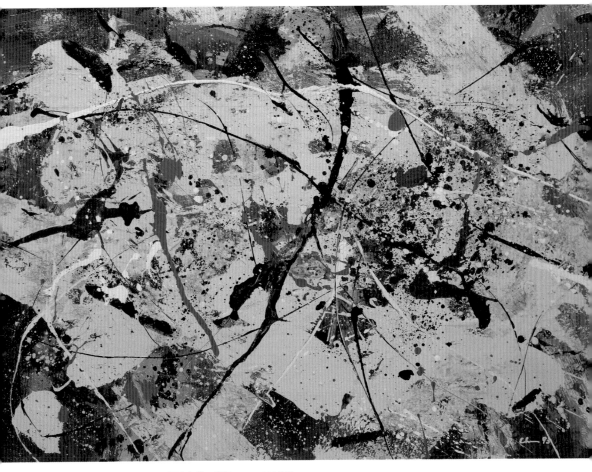

《莫斯科之冬》，1992-3，壓克力彩、畫布，89×130公分
WINTER IN MOSCOW, 1992-3, acrylic on canvas, 89×130 cm

Artistic creation is the strenuous engineering of culture. The parameters chosen by each artist effects the lengths to which he will go, in pursuit of his art. Chen says:

"If the tiers of artistic creation can be likened to the tiers of a pyramid, they would number roughly three. At the tip of the pyramid are the precious few who establish new artistic value systems spanning different eras, including the trailblazers and pioneers of different schools of art such as Picasso, Matisse, Kandinsky, and Duchamp. Like scientists such as Newton and Einstein, these artists not only establish new artistic value systems, but also initiate new artistic vision. Their perspectives have enormous impact on the development of art, and they must be credited for their monumental contribution. The second layer consists of those artists with established personal styles. These artists are able to accomplish the not-small feat of establishing their own unique artistic language and look, and can be counted among the number of accomplished artists. They would be even more commendable if they can make consistent breakthroughs from their existing styles, and present the substance of their work through new guises. The bottom tier consists of the vast number of average artists who were unable to establish personal styles."

Furthermore:

"The true artist is unconcerned with whether or not an audience can understand or appreciate his creations. Even if it does sell paintings and relieve financial pressures, when the artist paints art market-oriented pieces to please the laymen, he is only pandering technique; doing this only undermines the value and future of his work. In order to create truly exceptional art, artists must therefore "take fortune and fame lightly, and view wealth and social position as a wisp of cloud". Truly successful artists are those who create as a profession, and are proud of it."

These are clearly the standards by which Chen Cheng-Hsiung chooses to measure himself as an artist.

As a professional creator, Chen Cheng-Hsiung has always been devoted to learning, researching, and writing. He is a collector and researcher of Taiwanese aboriginal art, as well as an authority on Chinese imperial costumes. He has written extensively on contemporary art, especially on the subject of abstract painting. In 1991, he wrote the book "Abstract Painting" for the National Taiwan Museum of Fine Arts; in 1992, he wrote "The Birth and Development of Abstract Art," published by the Taipei Fine Arts Museum.

In recent years, he spoke often in China, and was commissioned by Tsinghua University's Academy of Art & Design (Beijing) to write the book

"On Abstract Art." With the publication of "The Sayings of Chen Cheng-Hsiung on Art," we are now able to go deeper into the mind of the artist through his academic prose. It is the perfect introductory book for art lovers, creators, and collectors alike.

Hsiao Chong-ray

May 2012
(The Author is a Professor of Art History in the
National Cheng Kung University, Department of History.)

陳正雄畫語錄 一三六

Preface

In the Style of Kandinsky

1

While visiting world-renowned abstract painter Zao Wuo-ki in Paris, we had the following conversation:

I pointed to a triptych in his studio and asked: "What inner experience, realization, or concept are you conveying through this work?"

Smiling, he answered: "Ha! If I could tell you, I wouldn't have painted it!"

Aha! His friendly derision sparked a sudden realization—*painters don't speak, they paint.* Put another way, painters paint in place of speaking.

But, as I walked out of his studio, I thought that was not necessarily true. Was Wassily Kandinsky (1866-1944), the founder of abstract painting, not a speaker as well as a master painter? During his professorship at the Staatliches Bauhaus in Germany, he published *Concerning the Spiritual in Art*, *Looking Back* (his memoirs), and *Point and Line to Plane*.

Let's think about this. Had Kandinsky only painted and not spoken out, we today could not possibly understand his original objectives for creating

abstractionist painting. The best we could manage would be obsessive and aimless conjecture. Furthermore, we might have come to believe that his works were nothing but self-indulgent graffitis, or descended to misclassifying spontaneous painting and decorative motifs as abstract paintings. Had that been the case, we would not have been able to ascertain the true intentions and reach of the abstractionist concept, and the idea might have been lost in the confusion. It is clear that Kandinsky had to paint as well as speak.

Chen has not only won the Florence Biennial's two highest honors—the Lifetime Achievement in Art Award and Lorenzo il Magnifico Award, he has penned *Abstract Painting* (National Taiwan Museum of Fine Arts), *Entering the Abstract World* (joint authorship, Taipei Fine Arts Museum), *On Abstract Art*, (Tsing Hua University Press, Beijing), and now, *The Sayings of Chen Cheng-Hsiung on Art* is published- the first ever book of its kind by a Taiwanese artist.

This is undoubtedly what Kandinsky himself had done.

2

The Sayings of Chen Cheng-Hsiung on Art is written in the time-honored quotations format.

This format has been popular since mankind's Axial Age (800BC-200BC). Ancient Greece had the *Dialogues of Plato*, and in China, Confucius' pupils compiled the *Analects of Confucius*; neither has lost their potency after

陳正雄畫語錄

一三八

millennia. With regard to the authors, the reason for this longevity lies in their indulging in the greatest freedom of expression, allowing an uninhibited prose and an energetic leaping from one thought to the next, unrestrained by the demands of logic. For the reader, it means the expression of profound principles from the author's psyche in the cleverest, simplest, and most perceptive language, recommending a great amount of information through a short reading, and accompanied by a strong push for creative thought.

Chen Cheng-Hsiung has been painting professionally for six decades, recording his zen-like revelations as they occur to him during artistic creation. Fluent in English and Japanese, he has traveled the world to befriend its most prominent painters. This most active and fruitful form of exploration—the reading of human minds—often gives rise to creative sparks, which he would immediately put down in his journal. He is also a popular seminar lecturer often invited to higher education institutions around the world, where he has had the chance to encounter many a unexpectedly "smart question" from sharp, young minds. The 106 sayings printed here are the culmination of all of these experiences and encounters.

There is an old chinese proverb describing the fruitful dialogue: "One conversation with a wise person is worth more than ten years of study." In reading this book, you the reader are shattering the ten-year mark. Chen Cheng-Hsiung has distilled 60 years of truths realized into 12,000 words. Put in another way, you the reader need only one hour to absorb the wisdom of six decades. You have only to presume, that if your IQ is twice that of the author, "the

godfather of abstract painting in Taiwan," you'll have learned more than you would in 30-years'study!

<div align="center">3</div>

Is this compilation a text written by one painter merely for other painters?

Taiwan's United Daily News is among the most influential newspapers for Chinese expatriates. Its arts & culture supplement is also a popular platform for Taiwan's art community. After reading the *Sayings*, its chief editor unexpectedly published them in a serialized format to great public acclaim. The greater portion of this readership is not comprised of painters, but a large community of arts and literature enthusiasts. Winning their good opinion means that the *Sayings* goes beyond a simple discussion of painting techniques to relate a journey traversing the great marketplace for artistic and thought innovation.

Here are a few examples:

——*Original works are immortal. Without originality, a work is dead before it is born.*

——*If you follow the same as others or walk in the footsteps of your predecessors, you will always be behind, and smothering your individuality. New paths are created by those who intentionally lose themselves in the wilderness—if there is no path before you, create one.*

——Breakthroughs are actually a accumulation method tracked along the axis of art history, adding more novel and intricate "formal expression", more "metaphysical meaning" that attunes more profoundly and compatible to current trends.

——The mechanism of innovation is self-subversion, which can be likened to self-mutilation. Both self-oppression and mutilation is self-inflicted pain. That is why the great German poet Goethe (Johann Wolfgang von Goethe, 1749-1832) said, "The fruits of art are sweet because its roots are bitter."

——Art is opening up a new visual space for all mankind. True innovation, however, is unpopular as it appeals only to the connoisseur; and all the while the artist must suffer this paradox as he aspires to popularity. Alas! This is the "original sin" of art, its fated flaw!

Reading these, it is clear how applicable the *Sayings* are to the creator of all.

This compilation will be an inspiration to all painters, a catharsis, resonating passionately with common cause and feeling in others advocates of originality

一四三

4

Only that which flows from your heart can, like a mountain stream, flow smoothly into the hearts of others.

The Sayings of Chen Cheng-Hsiung on Art is just what has ebbed out of 60 years of heartfelt artistic exploration.

Zu Wei

Paris

September 2010

Writer Zu Wei resides in Paris and is the author of An Ode to Joy on Canvas—Chen Cheng-Hsiung, the Pioneering Master and Laureate, a professor at Shanghai Tongji University, and consultant to the Bureau of the Shanghai World Expo Coordination (2010 World Expo)

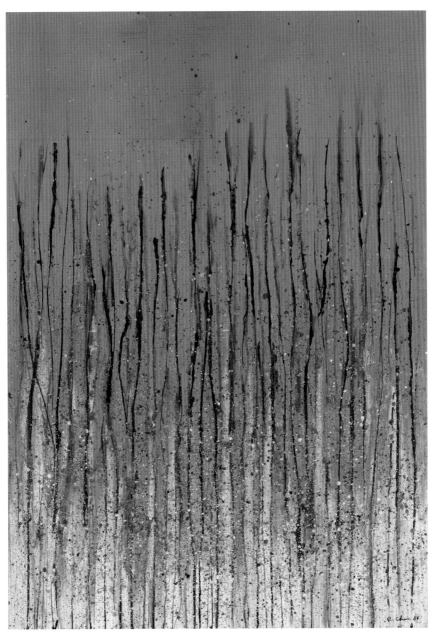

《春之竹林系列》，1984，壓克力彩、畫布，89.5×130公分
SPRING BAMBOOS SERIES, 1984, acrylic on canvas, 89.5×130 cm

The Sayings of Chen Cheng-Hsiung on Art

I. Artistic Ideal

1. Art is not the expression of surface experience, but of underlying truth, because this deeper truth is more pure and indicative of human nature.

2. It is my aim to explore and communicate the only truth I firmly believe in – the truth of the inner experience (feelings, emotions, moods); and through the basic elements of painting and aesthetic form, to explore the mysteries of the inner world, and transform invisible experience into visible reality.

3. I firmly believe that a true artist is ultra-sensitive to certain types of experience, and is able to integrate these inner experiences and present them with great intensity through his work. When he is creating, he is conscious only of the need to communicate his own inner experience and not at all interested in merely making record of his perceptions.

4. The nature of my art is "evocative" rather than "descriptive". Like music, it is meant to stimulate inner feeling rather than tell a story. It is intended as an intense expression of the inner experience—a "visual metaphor", not a "visual narrative".

5. In realism, the artist depicts the actual world as seen through the naked eye,

with the aim to "emulate nature" as Aristotle proposed, often making only a record of the outward appearance of nature or actual world; since the invention of the camera, photographers have already taken the emulation of nature to the limit. If today's artist is able to convey conceptual truth or the truth of inner experience through his works, his art would be more true, meaningful, and self-revealing.

6. Artistic innovation is a compulsion of intuition, expressed or conveyed by the artist using the basic elements of painting. Art theory is usually only developed years after the appearance and summation of innovative works; in other words, there must first be artwork before there can be art theory. Therefore, art theory is retroactive and does not guide innovation; the two complement each other, and theory plays the assisting role.

7. The creation of modern art is conceptually driven. Should the artist not possess unique conception, but only creates blindly, his work will be buried by the dust of ages. The creation of art is a personal matter. Only individual talent can be distinctive, and only through the infusion of individuality can a piece of art stand alone and be preserved in art history.

8. Inspiration is always and everywhere present, but only the "clever hands" of the artist can seize the opportunities presented and capture their explosive originality. Artists, like composers and poets, must first possess an abundance of emotions and a profound mastery of his art, so as to deftly capture inspiration as it presents itself, and express it through the elements of painting for a compelling masterpiece.

9. Original works are immortal. Without originality, a work is dead before it is born.

10. Do not tread upon the beaten path or follow in the footsteps of those who have gone before, or toy with the same things as others do. When all you see around you seems familiar, mere facets of the selfsame idea, do not continue down that path, even if it is mainstream, and lauded in public opinion. If you follow the same as others or walk in the footsteps of your predecessors, you will always be behind, and smothering your individuality. New paths are created intentionally by those lost in the wilderness—if there is no path before you, create one.

11. Artistic creation is self-expression, but it can convey the emotions of a people, or of mankind. The source of creation is not necessarily confined to emotion, but the artist must be like a gold-digger, allowing profound and subtle new ideas to pan out after tens of thousands of attempts. This is the only way to magnify the individual and speak for all mankind.

12. The creation of art is strikingly similar to genetic engineering. The creation

of a new breed must employ new genes to create new genetic chains; it is the same for the artistic creative process. If one wishes to create new styles, forms, and content, one must employ novel combinations of artistic "genetic" material. Subversion and reconstruction is the genetic engineering of modern art. I myself utilize the concept of "genetic engineering of the modern painting" to reconstruct and make breakthroughs. For me, every breakthrough and subversion implies even more and even greater challenges and adventures, when there are no breakthroughs and subversions that are even more unrestful and painful.

13. The artist must establish a personal store house of art "genes", and know how to seek out the genes of novel art contained in the storehouse of alien cultures (i.e. cultures foreign to the artist's own). Once he has extracted them. He finds the way to create new species and produce unboundaried works of art. This is the best policy. I have extracted two such "genes" from Taiwanese aboriginal art: intense, striking colors, and a vibrant life force, I also draw on the imagery and musicality of Kuang Tsao, the most freely cursive style of Chinese calligraphy. These elements have provided me with new creative genetic chains for new artistic creations; my creative process, my painting, is actually a kind of genetic engineering.

14. The creative forces within culture can be likened to genetic recombination in an organism; a diverse cultural genome will naturally lead to a fluid creative-vitality and achievement. It is therefore important to acquaint oneself with, and learn as much as one can of different cultures, to create opportunities for exchange, and to understand and appreciate them. To discount culture is to

slaughter creativity.

15. Creation is the recombination of existing elements. It is not creating something out of nothing, but the recombination of existing elements for dissimilar results. In the realm of natural science, creation indicates advancement and enhancement. In the art field, however, rather than calling creation "progressive", it should be claimed as a new discovery from mankind's preexisting reserve of "visual forms". Art history as a whole is, in actuality, a record of "visual form" discoveries, therefore one cannot say that there has ever been artistic advancement or lack thereof.

16. The three DON'T-S of painting: (1) DO NOT imitate the old masters: paintings must not be modeled upon past works—do not tread the beaten path, but step away from antiquity;(2) DO NOT imitate your contemporaries: Imitating one's contemporaries is the same as imitating the ancients; (3) DO NOT imitate yourself: Do not copy and recreate your own works, but bravely challenge your past to create new content and new looks to enhance the artistic value of your work.

17. The essence of art is innovation, and innovation requires great pressure, without which there can be no breakthrough. This pressure is not born of external forces, but from within. If an artist were to paint leisurely and without pressure, there can be no breakthrough, much less innovation. The mechanism of innovation is self-subversion, which can be likened to self-mutilation. Both self-oppression and mutilation is self-inflicted pain. That is why the great German poet Goethe (Johann Wolfgang von Goethe, 1749-1832) said, "The

fruits of art are sweet because its roots are bitter".

18. It is the best and most fortunate thing for one's interests and enterprise to complement each other. However, as passion for artistic creation could lead to economic frustrations, the artist should be mentally prepared. If he wishes to do what he loves, he must face whatever obstacles may come his way. To see results, he must not easily give up, compromise, or betray his original intentions when met with setbacks. The course of artistic creation is wrought with difficulty and without shortcuts.

19. Art is not a sprint, but a life-long marathon. Through long periods of hardship and solitude, the artist must show the determination and professional spirit exemplified in the proverb: "It takes a long road to show the strength of a steed."

20. "Life is short, Art is long". Art is both a fleeting and an eternal awareness of life, and the creative process is a long, lonely, and difficult road. The true artist is preordained to a life of perseverance without complaint or regret.

21. I do not believe that artistic creation needs be equated with the pain, misfortune, and other negative forces in life. Not every famed master in art history lived in misery. Reubens (Peter Paul Reubens 1577-1640) was an optimist, Goya (Francisco de Goya, 1746-1828) knew how to entertain himself, and Van Gogh (Vincent van Gogh, 1853-1890) was very pleased with his own paintings. I feel there is nothing more interesting on this earth than painting. I believe that the life of the artist is an intoxicating dream. If I do not

一四九

paint or meditate for even one day, my heart feels that something is missing. Art is my faith, my all.

22. Meeting and speaking directly with a master of art or great thinker is an effective way to pick their brains, to draw from their unique thought process and lifestyle, as well as their artistic concept, technique and experience, into one's personal artistic gene pool, to be employed in the search for new "species" in one's personal artistic style.

23. Breaking through traditional thought, techniques and demands is the only way to develop the innovative process; this is almost a self-evident truth. But this type of breakthroughs is actually an accumulation method tracked along the axis of art history, adding more novel and intricate "formal expression", more "metaphysical meaning", that attunes more profoundly and compatible to current trends.

24. The artist must not only accept, but also enhance tradition. The greater his understanding of tradition, the easier it will be for him to enhance it.

25. Art is a visual language, pure plastic elements- the combination and composition of color, shape, space, lines, and dots. Therefore, characters alone are not enough to convey its inner meaning.

26. Camus (Albert Camus, 1913-1960) once said, that artists toil for beauty and pain; I toil for beauty and joy. The modern man is pained enough by stress, anxiety, impatience, disorder, and emotional turmoil, and that is not what

I wish to present. The people already suffer enough, and I don't want my audience to feel more gloom and depression. I wish to paint the happy, joyous, passionate, bright, free, and beauteous side of life, to allow man to regain visual joy, comfort, and freedom, as Beethoven did with his "Ode to Joy". I wish to create my own "Ode to Joy" on canvas.

II. The Artist

27. There are three types of artists: (1) The commercial or movie star artist is like a film/music star, adept at showmanship and publicity, and excels at marketing himself; (2) the professional artist creates first-rate, original pieces, but is unwilling to put on a show, not good at marketing, and not very prominent; (3) the last is a hybrid of both—the first-rate artist who can traverse freely through both the commercial and artistic aspects of art.

28. The accumulation of consistent contributions over a long period of time in what earns an artist recognition in the annals of art history. However, as the new will outshine the old, unless older-generation artists can advance with the times and maintain an innovative effort, they will be forced offstage like a bygone fad or outdated electronics. Should that happen, the consistent accumulation of works would be interrupted, and all their previous efforts for naught.

29. Because modern art is unbounded, in this e-era of advanced information exchange, the modern artist is not only charged with the mission to inherit local traditions, but also carries the responsibility to create a new art that is internationally-relevant.

30. It is regrettable that such trappings of appearance as commercial packaging and applause can more easily blind the modern artist, that they neglect the inherent power of art to arouse emotion, which is the only way to affect art history.

31. Fame is a good thing, but one must not march in place once it is achieved. Instead, one should more vigorously apply oneself and strive for further breakthroughs, which is the only way to continuous innovation as well as greater achievement and fame. It is the collective lament of artists that "fame is easy to achieve, but difficult to maintain."

32. Art is opening up a new visual space for all mankind. True innovation, however, is unpopular as it appeals only to the connoisseur; and all the while the artist must suffer this paradox as he aspires to popularity. Alas! This is the "original sin" of art, its fated flaw!

33. To put on a show is to blaspheme against artistry. Some artists like to put on a show, that doesn't benefit the creative process, but only interrupts it.

34. Everyone can learn to paint, but not everyone can be an artist. In the course of human history, those who have engaged in the creation of art are so numerous as to number the stars, but only a pitiful few have been recorded in the annals of art history. This tells us one thing: artists are engaged in a colorful yet high-risk enterprise, an occupation without retirement. I would like to advise students of painting, that the aim of learning to paint is to bring yourself into contact with beautiful things, for the enrichment of your personal life, not to

become a professional painter. It is my joy, that a joyous learning experience will cultivate in students the ability to appreciate art, as well as characters and tastes as wonderful as a work of art.

35. In the half-century since I began studying painting at the age of 17, I have always been "at school", ceaselessly pursuing new academic degrees, without the option of graduation.

36. If the tiers of artistic creation can be likened to the tiers of a pyramid, they would number roughly three. At the tip of the pyramid are the precious few who establish new artistic value systems spanning different eras, including the trailblazers and pioneers of different schools of art such as Picasso, Matisse, Kandinsky, and Duchamp. Like scientists such as Newton and Einstein, these artists not only establish new artistic value systems, but also initiate new artistic vision. Their perspectives have enormous impact on the development of art, and they must be credited for their monumental contribution. The second layer consists of those artists with established personal styles. These artists are able to accomplish the not-small feat of establishing their own unique artistic language and look, and can be counted among the number of accomplished artists. They would be even more commendable if they can make consistent breakthroughs from their existing styles, and present the substance of their work through new guises. The bottom tier consists of the vast number of average artists who were unable to establish personal styles.

37. The true artist is unconcerned with whether or not an audience can understand or appreciate his creations. Even if it does sell paintings and relieve financial

pressures, when the artist paints art market-oriented pieces to please the laymen, he is only pandering technique; doing this only undermines the value and future of his work. In order to create truly exceptional art, artists must therefore "take fortune and fame lightly, and view wealth and social position as a wisp of cloud". Truly successful artists are those who create as a profession, and are proud of it.

38. Exhibiting is one way to become a professional painter, but it is not everything. Prizewinners will not necessarily develop better careers than those who did not place, because recognition is, at best, representative of only the beginning of a career. I believe that humility, effort, self-confidence, passion, and persistence are what makes a successful painter.

39. The instant success story has become a common phenomenon, but the establishment of a unique artistic style is not among the many professions for which this is possible. For true art, the creative process is always long and treacherous and without shortcuts. Art cannot be rushed. The road to success is wrought with great pains and lonely accomplishments over a long period of time. Unfortunately, as the pace of life has quickened over time, many modern artists are taking the McDonald's fast-food approach to art—pumping their works with hormones, in hopes that they will grow quickly.

40. Unlike athletes and music stars, artists do not become accomplished after just five to ten years of short-term effort and training. The soil of artistic creation requires long tilling, and the artist must invest his life and passions whole-heartedly for his efforts to germinate, blossom, and yield fruit.

41. A painter must possess the following distinguishing characteristics: first, determination—he must firmly defend his artistic standpoint, and persist in his creative beliefs without betrayal or compromise, from first to last. Second, the spirit of professionalism—he must be loyal to his art and to himself, and not be distracted from the true path. He cannot "sell hot in winter and cold in summer", catering to the taste of the art market. Only those armed with determination and the spirit of professionalism, without complaint or regret, can become true painters!

42. A painter must seek out a unique, individual vocabulary for painting, not just avidly imitate the verbal wisdom of American and French masters. As good as an imitator could possibly be, he will forever remain in another's shadow, and will never possess his own "brand name."

43. Only average painters and writers will docilely employ the language of others when it comes to their own paintings. The true artist has a profound understanding of the principle that "the student must surpass his master", and would never be satisfied with being his master's equal.

44. Style is the hallmark of a painter, a way for the artist to express his individuality and thought, and imbues his works with a prominent personal flare. By establishing a personal style, the artist is creating his own language of painting and unique appearance. From this perspective, an exceptional painter must also be an exceptional art linguist.

45. Establishing a personal style is difficult, but making a breakthrough or subverting one's existing style is even more challenging. The artist's most difficult task is to continually surpass himself, search for new breakthroughs and subversive maneuvers, and present the substance of his art through new faces. When an artist's creative style ceases to evolve, and he no longer has the capacity for breakthrough, it implies the death of his artistic life.

46. The great artist must be 10 or 50 years ahead of his time, perhaps even more.

47. The pioneer and rebel in art are not afraid of challenges. He not only wants to surpass others, but to surpass himself. Even if he has surpassed everyone else, he can not rest on his laurels, because the greatest challenge is to surpass oneself.

48. Like the great scientists Newton and Einstein, and great explorers Marco Polo and Columbus, a great artist must possess a fearless spirit that pushes him courageously onward; a type of guileless naiveté that leads the explorer within him deep into the wilderness of art.

49. Whenever a new school of thought reveals itself in the art world, it is inevitably met with attack and abuse from the conservative camp, and a lack of strong convictions and faith could only mean defeat. The road traveled by the innovative artist is a long, lonely, and difficult one.

50. Under communist regimes, the government undertakes the care of artists. The over-protected artist is like a parrot in a cage—his creative energies and

spirituality are eroded by a life of leisure, and is unable to wing himself to great heights or propel far-reaching waves like the great proverbial roc (an immensely powerful bird of Chinese myth, capable of ascending to heights of 90,000 feet) and leviathan the ancient Chinese philosopher Zhuāngzǐ spoke of.

51. As in the case of Kandinsky (Wassily Kandinsky, 1866-1944), we see that an artist can also be a theoretician. However, artists cannot also be art critics, for the same reason that contestants cannot also be judges. Some artists/critics grow so drunk with power that they cease to be artists and critics, but become art brokers.

52. Picasso (Pablo Picasso, 1881-1973) and Matisse (Henri Matisse, 1869-1954), two great artists of the 20th century, each created their own unique set of artistic values, which comprehensively influenced the development of 20th century art. The paintings they accumulated over their respective lifetimes were diverse in theme and style, multifarious and rich, with varying contents and styles during each period. Especially precious is the sense of freedom their works convey, like vitamins for the modern artist, as well as the modern man.

53. When an artist reads an art publication, he should not only browse its pictures, but also read and comprehend its text in order to grasp unfamiliar intellectual concepts and creative backgrounds, to enhance his ability to understand and respond to those works.

54. The International Biennial of Contemporary Art is like a large marketplace: when the wares are good (innovative), they are admired, and when they are

bad, they inspire no interest. This international market provides not only countless subjects of study; when a painter is invited to an international exhibition where he can compete with painters from different countries and regions, new agitating factors can be created within him, which will inspire future strokes of such genius that will surprise even himself.

III. Artwork

55. Artwork is the most perfect object for beautifying space, and walls are in its service. A good piece of art can render a cold, drab wall radiant with life and spirit; moving like the hand of God in the creation of Adam, it bestows breath, energy, and spirit.

56. A purchase of paintings offers the greatest encouragement to a professional artist, and the most practical contribution to the beauty-creation industry. It is a tool for encouraging the professional painter to keep working. With encouragement from all sides, the artist can focus all his energies on creation.

57. Tycoons often spend large amounts of money for paintings by the masters. Among them, a number are in fact art-lovers who recognize the value of true art. But there is also a number who purchase art for the purposes of investment and tax exemption, the veneer of elegance, or building a philanthropic reputation. No doubt this is done to perfume their exterior and to lend a fragrant aroma to odorous coin. Even so, this "invisible hand", coined by Adam Smith, a noted economist, will stimulate the artistic climate and standards.

58. In the past, charitable giving by affluent Chinese reflected cultural and religious mandates; outside of karmic considerations, they were miserly. In the past 20 years, there has finally developed a sense of giving back to society, and entrepreneurs have been setting money aside for the establishment of cultural and artistic foundations to promote related work. For the Chinese, this is an incredible cultural turning point. Affluent westerners, including the Medici family of 16th century Italy, and Rockefeller and Paul Getty of the U.S., have been model nurturers of art for a long time. Affluent Chinese are five centuries behind the Medici's.

59. What determines the value of a work of art—whether it is good or bad—is not beauty, but originality and substance.

60. What is art will always be art, and true art will always be recognized and vindicated. Works that are deprived of innovativeness and inferior of quality, popular due only to marketing or regional enthusiasm, cannot enjoy lasting fame. Influences from the human element can only be transitory, and cannot stand the test of time.

61. A good work of art should be a breath of fresh air for its viewer; only then can the work of art have life that lives up to its name.

62. A large painting can be difficult to work, but a small painting is no easy task either. An image cannot be enlarged like a photograph for a large work, which must have sufficient structure and content to support it. A painter must possess firm foundations in technique and artistic mastery to create a majestic

and awe-inspiring large work. When creating a large work, one must take great care to avoid the impropriety of subject to size, and consider that big is not always better. It is because of the aforementioned virtues that the large abstract paintings by Jackson Pollock (1912-1956) possess the power to awe its viewers. In contrast, a small painting is the establishment of a great and splendid universe in a small space. An exquisite small work can only be called great if it can project the same feeling and power as a large work. The small paintings of Paul Klee (1879-1940) inspire just such sentiments—infinite richness on a mere foot of canvas, and worthy of long study.

IV. My Words, My Paintings

63. Through color, each of my works expresses the vivid movement and joy of life in nature.

64. Every one of my paintings is done with the spontaneity that comes from unbroken meditation. Buonarroti Michelangelo (1475-1564) used to meditate in front of a piece of marble until the marble itself seemed to move. Only then did he take up his chisel. Before I put my brush in motion I sit in front of the canvas and stare at the untouched surface as if in a Japanese tea ceremony. I meditate until mental images arise then I convert them into form and color. As I do so I chant rhythmically, 'Ah, this is how I want to paint.' Immediately, my brush starts moving and the inner experience buried within me begins to shoot forth onto the canvas. The time spent in contemplation sometimes exceeds the actual process of painting.

65. I have always believed Chinese characters to be the most beautiful written

language in the world, especially pictography, which has an innate fluidity, melody, and rhythm. This is the reason why I have made it a basic element of my painting.

66. Chinese characters are inherently musical, as is the relationship between each character. This is especially true of Tang Dynasty's cursive hand, which can be made a new element of creative art.

67. Color and line have always played an important role in my paintings. Not only do I liberate the two from their descriptive to their original capacity for a return to the most pure and simple form of painting, but I push simplification and purification to the limit—so that the work will be as pure as a musical composition, with a heightened spirituality.

68. Painting is a game of colors, as well as a game of the mind.

69. I've always believed that color can create its own forms and subject matter, as well as establish its own artistic space. It is for these reasons that color takes on such an important role in my work, and I have always strived to take the purification and simplification of color to the utmost.

70. My ideas stem from "essential art", from colors and forms, color bridges the gap between the visions and spirits of the audience and painter; allowing the audience to step through the entryway into a dazzling world of color, and elevating painting from the realm of the physical to the realm of the spiritual. Wassily Kandinsky said that abstract art is the arrangement and combination of

colors and forms; therefore, using essential art as the starting point will allow a more lively and well-rounded expression of colors and forms.

71. I never make a preliminary sketch when I paint, but give my paintings "a natural birth". I put paints to canvas directly, investing all my life and emotions into the act of painting—like a woman birthing naturally, not having life wrenched from her by the edge a knife. In this way, the life and inner emotions of the artist may avoid weakening or distortion, and his creations do not become unnatural and artificial. It is my belief that working carefully from a sketch would inevitably weaken the life force of the artist.

72. I base my creations on my experiences with and meditations on nature. The extensive atmosphere and brilliant pallet provided in nature gives me unending revelations and inspiration.

73. I am always faithful to my own inner world, and firmly convicted to abstract forms of expression, because it is the most pure form of expression for painting. This is a conviction that I will never compromise or betray.

74. Painting, for me, is more a labor of thought than of actual work.

75. I utilize oil, acrylic, and mixed media in my paintings, which cannot be completed in the same day like watercolors or ink paintings. In order to breakthrough and innovate, each painting is left in the same spot where it was completed, where I then proceed to examine it from each and every angle. Every painting is repeatedly modified. This process usually means

several months, even half a year of unceasing pondering, deliberation, and contemplation. Painting is a work of time and effort!

V. Abstract Art

76. Realistic painting, like the libretto of a song—it's beautiful, all right, but the feeling expressed is limited, and, in time, it comes to an end, places a twofold restriction on the imaginations of both its creator and audience, but, abstract painting is like instrumental music, it is a kind of symphony of color; it evokes a life of infinite richness, its scope like the ever-expanding universe in which creator and audience alike can take free reign of their imaginations. It is 'visual music'.

77. The aim of abstract painting is to awaken the beauty and feelings buried in life's most profound depths.

78. The creation of abstract art can be truly moving only if it stems from an intense inner need that is inseparable from practical life experiences.

79. There is a lack of freedom in life, but abstract art allows the mind a freedom to adjudicate and accept aesthetic beauty, giving the spirit license to soar.

80. I am always loyal to my inner world, unrelenting in my persistence for abstract forms of expression because it is the purest form of expression. With abstract art, "I wish always to be birds winging together in the heavens, and roots entwined in the earth."

81. Poems are formless abstract paintings, while abstract paintings are soundless poems, the poetry of space.

82. Creating a living environment that is conducive to abstract art appreciation is the best way to enhance it. By placing a few quality pieces in the home or office, so that one can be immersed in such an environment through living and working alongside them, the growth of appreciation will be almost osmotic. Like listening to classical music at home will heighten your sensitivity to musical beauty, the realization of abstract meanings through experience is a sound strategy for the elevation of one's aesthetic sensibilities and taste.

83. The issue is not whether one can appreciate abstract art, but whether one can break away from antiquated concepts and take time to learn about it, study it, and approach it with sincerity.

84. The human race entered the digital age at the end of the last century, and the virtual space, constructed of the elemental digits '0' and '1', has completely redefined the way the human race lives. Through the World Wide Web, mankind has entered an infinite space where information is both vast and endless, a fantastical, intangible space that I so vehemently wish to manifest through painting. I believe that this abstract third dimension can only be efficaciously displayed through abstract painting, whose only pursuit is the expression of inner experience.

85. The definition and spirit of abstract painting are often misinterpreted, misunderstood, and misdirected. As those who do not understand it will

mislead others, phrases such as "an abstract landscape" have been created by both Taiwan and China. The adjective "abstract" renders any form unrecognizable and unnamed—how then can any landscape so described be distinctly recognizable? The phrase "abstract landscape" is clearly illogical. This lack of understanding in both China and Taiwan for abstract theory leads to much misuse of the term "abstract painting."

86. Some believe that the concept and spirit of abstract painting existed in ancient China, even that it has been a part of Chinese art for 3,000 years. In actuality, Chinese art, under the guidance of the ancient "spirit of moderation" and "golden mean" philosophies, had never truly ascended to the pure and complete realm of the abstract, but remained mired between representation and abstraction. From the philosophies of Tang Dynasty Chinese ink painter Chang Yen-Yuang, who said: "In painting one should especially avoid a meticulous completeness in formal appearance and coloring." and Northern Sung Dynasty's Su Tong-pou, who said: "Practicing painting in terms of formal likeness, The approach is close to that of a child.", we see that Chinese ink painters at the time were held up (or shifting) between representation and abstraction.

87. Born in the early 20th century, the concept and spirituality of abstract art is entirely different from prehistoric Chinese painted pottery and the motifs on 3,000 year-old Shang and Zhou Dynasty bronze implements. The greatest difference between them is that while the motifs on the aforementioned artifacts are abstract, they belong in the category of decorative art, not plastic art. Decorative art is created to be practical and decorative, and are not signed;

abstract painting is constructed and pieced together using the elements of form, color, line, and space, cares particularly for the complicated arrangements and relationships of visual elements-form, color, line and space, is born of the inner needs of the artist, conveys the truth of the inner experience, and explores the mysteries of the inner world. For these reasons, both arts cannot be confused.

88. Color is an important topic in one's artistic development toward the abstract. There are only two possible paths on the journey toward the abstract: one originates from color, and the other from form. Wassily Kandinsky, Robert Delaunay (1885-1941), and Frantisek Kupka (1871-1951) took the path originating from color to a new artistic realm; and Piet Mondrian (1872-1944), and Kasimir Malevich (1878-1935) both ascended to new heights on the path originating from form.

89. Looking back on a century of Taiwanese abstract art, there are abundant instances of artists switching disciplines halfway or deserting abstract art outright. Perhaps this is due to the arduousness of innovation, the loftiness of an art misunderstood and deprived of resonance, and the difficulty in maintaining a living when one lacks the acknowledgement of collectors.

90. To promote abstract is to propagate faith in beauty. To that end, I have been spreading the word in both China and Taiwan, a self-appointed missionary of abstract art, working hard to make myself a "promoter of beauty".

VI. Chinese and Western Art

91. Chinese and western paintings do not share similar mediums, tools, or ideas of beauty. And as both science and philosophy declare that cross-category quality comparisons cannot be made, one must not look down on the other, but should draw on each other's strengths, and create a blending of their unique individual characteristics. Norbert Weiner (1894-1964), the originator of control theory, once said that the point at which two separate disciplines intersect is often the bed of a new discipline. If that is so, then we can expect the birth of a new art form from the meeting of eastern and western art.

92. The first time China absorbed large amounts of alien culture was during the Southern and Northern Dynasties period (425-529 D.C.). With the Xianbe tribe to the northeast, India to the south, and the Tupot, Persia, and even the Roman Empire to the west, Chinese art transformed and evolved ceaselessly, culminating in the artistic golden age of the Tang Dynasty.

93. Modern art has overthrown the classical standard of elegance. In the face of this worldwide artistic current, Chinese artists must be uninhibited and open about drawing from and absorbing alien cultures to mingle with our own. This is the way to creating more expansive, resonating, and appealing works, as well as a special characteristic of Chinese culture, which declares: "broad-minded leads to magnitude". It is not enough for the modern artist to draw from the technique and experiences of his forefathers, but he must take from alien culture. By alien culture, I mean a culture completely different and foreign to the artist's own. For western artists, alien cultures include Chinese

calligraphy, Japanese ukiyoe, eastern wood-block printing, Zen painting, Taiwanese aboriginal art, African and Oceanian wood carving, painting done by children or the mentally handicapped, etc. From these, artists can derive inspiration and revelation to begin new schools of art, as Picasso had from traditional African carvings, creating an enormous breakthrough. Van Gogh received revelation from ukiyoe, as his colors became more vibrant and he developed calligraphic lines. And the abstract artists Hans Hartung (1904-1989), Pierre Soulages (1919-), and Franz Kline have all derived inspiration and revelation from Oriental calligraphy and created calligraphic abstract paintings rich in rhythm and melody.

94. Long investment in and devotion to artistic innovation, a thorough understanding of traditional folk art that provides artistic nourishment, and a comprehensive knowledge of the essences drawn magnanimously from alien cultures, will aid in the establishment of a personal artistic style.

95. Some people say: "modern paintings are paintings created by modern people." This is just as illogical as saying, "Chinese paintings are paintings painted by Chinese people", because some modern artists remain entrenched in the creative concepts of the 18th and 19th centuries, and some paintings by Chinese artists resemble those done by western painters. Modern art in Taiwan and China has not yet broken free from imitating the West. Paintings by Chinese artists are still entirely entrenched in western techniques and concepts, and only dotted with elements of eastern technique and regional uniqueness, inspiring a sense of déjà vu.

96. Western styles can be borrowed, but artists should still build on a foundation of eastern style. Only a broad basis of eastern art has the potential to successfully incorporate western styles. Chinese artists must understand how to extract the marrow from traditional Chinese arts and culture in order to transform it, through borrowing from western styles, into a relevant modern visual language, with which to create a visual art form with eastern uniqueness. This is the boulevard by which Chinese artistic innovation will reach the world.

97. Integrating western performance tools and forms, or drawing from western experience, is the only road to advancing Chinese ink painting. Ink painting is a uniquely Chinese art form, manifesting Confucian, Taoist, and Buddhist thought through the appeal and artistic conceptions of brush and ink. However, since the early Song Dynasty period when the shih-cheng (to study under the master(s) of only one particular school) and imitation trends originated, Chinese ink painting techniques have been mostly bogged down by traditional techniques. Because most modern painters remain traditional and guarded against outside influences, so much of present-day Chinese art is anemic and heading towards a dead-end. Intimidated by the idea of innovation, their chronic illness results from a lack of broad cultural "nutrition". The way out of this predicament is to innovate through partaking in western techniques and freeing oneself from imitation.

98. Not all innovative themes and techniques of the modern Chinese artist must belong to China, though spiritually he must return to his roots. Because tradition is a rich asset, an artist should never forget the tradition that he is a part of, nor be satisfied with being a regional artist, but make development into

an international artist his professional ambition.

99. For the eastern artist to become international, for him to find his true self, he should fully express, through his work, traditional eastern beauty and the artistic consciousness embedded in eastern culture. If he cannot find his roots and orientation, foreign artists will not recognize eastern art. It is for this reason that I have been searching my whole life for a meeting of eastern and western cultures.

100. Modern artists should have the vision and breadth to "set firm foundations at home and cast his ambitions abroad". He should not be content only with domestic accomplishments, but step out onto the international art stage to communicate and compare his experiences. A painter is like a sports team, and must frequently take part in international competitions to know his own strength, or else he is only a country bumpkin who knows nothing of his place in the great, wide world. However, it is far from easy to become a participant in an international exhibition, which is usually only by invitation from the jury or curator.

101. The 21st century is a time of great blending for eastern and western arts and cultures. Chinese art will become an important part of world art, and the international art stage expects great things from Chinese artists. Chinese artists must hold to the characteristic "acceptance makes great" trait of Chinese culture, and research both eastern and western cultures so as to gain a thorough understanding of, and integrate the two to create modern Chinese art. All mankind will surely recognize such a great contribution to the development of

world art, and its achievement is also an expectation I have for myself.

VII. Art Education

102. To become an artist, one cannot rely solely on institutional education, but must establish his own artistic outlook following graduation, and strive to walk his own path. A teacher is only an art educator, a guide or torchbearer, not an omnipotent artist. The purpose of art education is not to nurture contributors to the latest trends. Should the student learn only this from his teacher, they will become inevitably lost five to ten years down the line. For example, Taiwan museums host frequent exhibitions of installation art, the latest fad in Taiwan, though the art form is already in decline in the U.S. Should schools then teach installation art? From this, we see that the formulation of curriculums must be modernized. The aim is not to teach students the latest trends, but to train them in modern artistic perspectives and techniques, and train within them a consciousness for originality. In other words, instead of giving the student a bird, give him a gun with which to shoot one. That is the difference between being a teacher and an artist.

103. Paintings done by art school students are all quite similar and lacking in character. The instructor's main duty is not to correct the students' technique, but to assist students with their search for their personal language of painting through discourse.

104. Artists must be able to think for themselves, and be able to generate original thought. Art education at present is overly conservative and draconian, and cannot provide students with sufficient space for growth and self-expression,

even becoming a hindrance at times.

105. Much of what one learns in the classroom, in terms of texts and technique, is considered conservative and uncreative, mere traceries that are often passé, even wrong. Art education curriculums have been in a state of rigor for quite some time. New courses are required to close the distance between the curriculum and the latest developments in the art world. Art education out in society is more successful, making an impact despite its uncertain scope and scattered distribution.

106. Teachers will bestow upon their students the ideas and styles of their own generation, already out-dated and extinct before students are able to learn them. Therefore, students must surpass their teachers in striving to do something different.

SHOW藝術20　PH0110

陳正雄畫語錄

作　　者 / 陳正雄
英　　譯 / Ellen Wieman、陳正雄
責任編輯 / 王奕文
圖文排版 / 陳姿廷
封面設計 / 秦禎翊

發 行 人 / 宋政坤
法律顧問 / 毛國樑　律師
出版發行 / 秀威資訊科技股份有限公司
　　　　　114台北市內湖區瑞光路76巷65號1樓
　　　　　電話：+886-2-2796-3638　傳真：+886-2-2796-1377
　　　　　http://www.showwe.com.tw
劃撥帳號 / 19563868　戶名：秀威資訊科技股份有限公司
　　　　　讀者服務信箱：service@showwe.com.tw
展售門市 / 國家書店（松江門市）
　　　　　104台北市中山區松江路209號1樓
　　　　　電話：+886-2-2518-0207　傳真：+886-2-2518-0778
網路訂購 / 秀威網路書店：http://www.bodbooks.com.tw
　　　　　國家網路書店：http://www.govbooks.com.tw

2013年6月BOD一版
定價：500元

國家圖書館出版品預行編目

陳正雄畫語錄 / 陳正雄著. --初版. -- 臺北市 : 秀威資訊
科技, 2013.06
　　面；　　公分
　ISBN 978-986-326-113-1 (精裝)

　1. 繪畫　2. 畫論

947.5　　　　　　　　　　　　　　　102008838

讀 者 回 函 卡

感謝您購買本書，為提升服務品質，請填妥以下資料，將讀者回函卡直接寄回或傳真本公司，收到您的寶貴意見後，我們會收藏記錄及檢討，謝謝！
如您需要了解本公司最新出版書目、購書優惠或企劃活動，歡迎您上網查詢或下載相關資料：http:// www.showwe.com.tw

您購買的書名：＿＿＿＿＿＿＿＿＿＿＿＿＿＿＿＿＿＿＿＿＿＿＿

出生日期：＿＿＿＿＿年＿＿＿＿＿月＿＿＿＿＿日

學歷：□高中 (含) 以下　　□大專　　□研究所 (含) 以上

職業：□製造業　□金融業　□資訊業　□軍警　□傳播業　□自由業
　　　□服務業　□公務員　□教職　　□學生　□家管　　□其它＿＿＿＿

購書地點：□網路書店　□實體書店　□書展　□郵購　□贈閱　□其他

您從何得知本書的消息？

　□網路書店　□實體書店　□網路搜尋　□電子報　□書訊　□雜誌
　□傳播媒體　□親友推薦　□網站推薦　□部落格　□其他＿＿＿＿＿＿

您對本書的評價：(請填代號　1.非常滿意　2.滿意　3.尚可　4.再改進)

　封面設計＿＿＿　版面編排＿＿＿　內容＿＿＿　文／譯筆＿＿＿　價格＿＿＿

讀完書後您覺得：

　□很有收穫　□有收穫　□收穫不多　□沒收穫

對我們的建議：＿＿＿＿＿＿＿＿＿＿＿＿＿＿＿＿＿＿＿＿＿＿＿

＿＿＿＿＿＿＿＿＿＿＿＿＿＿＿＿＿＿＿＿＿＿＿＿＿＿＿＿＿＿＿

＿＿＿＿＿＿＿＿＿＿＿＿＿＿＿＿＿＿＿＿＿＿＿＿＿＿＿＿＿＿＿

11466
台北市內湖區瑞光路 76 巷 65 號 1 樓

秀威資訊科技股份有限公司　　　收

BOD 數位出版事業部

..

（請沿線對折寄回，謝謝！）

姓　　名：＿＿＿＿＿＿＿＿＿　年齡：＿＿＿＿　性別：□女　□男

郵遞區號：□□□□□

地　　址：＿＿＿＿＿＿＿＿＿＿＿＿＿＿＿＿＿＿＿＿＿

聯絡電話：(日) ＿＿＿＿＿＿＿＿＿　(夜) ＿＿＿＿＿＿＿＿＿

E-mail：＿＿＿＿＿＿＿＿＿＿＿＿＿＿＿＿＿＿＿＿